IMAGES
of America

CHICAGO'S
HISTORIC
PULLMAN DISTRICT

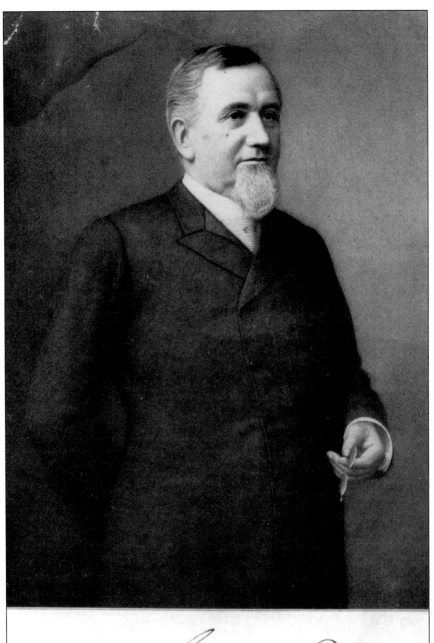

Born March 3, 1831 Died October 19, 1897

IMAGES
of America

CHICAGO'S
HISTORIC
PULLMAN DISTRICT

Frank Beberdick
and the Historic Pullman Foundation

ARCADIA
PUBLISHING

Published by Arcadia Publishing
Charleston, South Carolina

Printed in the United States of America

Library of Congress Catalog Card Number: 98087700

For all general information contact Arcadia Publishing at:
Telephone 843-853-2070
Fax 843-853-0044
E-mail sales@arcadiapublishing.com
For customer service and orders:
Toll-Free 1-888-313-2665

Visit us on the Internet at www.arcadiapublishing.com

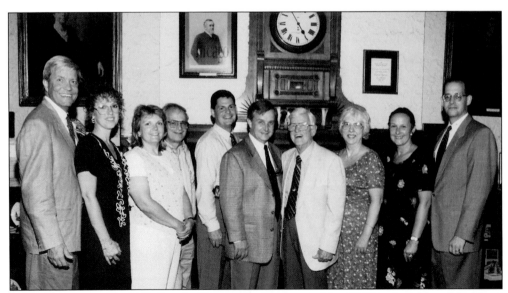

This photograph of the HPF Board of Directors was taken in May 1996 in the lobby of the Hotel Florence by Jeff Brown. From left to right, they are as follows: Robert Fioretti, president; Deborah Bellamy-Jawor, executive director; Cynthia McMahon; Thomas Zarris, PCO ex officio; Robert Cole; Michael Shymanski; George Ryan; Betsy Baird; Judith Kubida; and Richard Daspit Jr.

CONTENTS

ACKNOWLEDGMENTS

This modest volume began with an idea to make some of the material in the Historic Pullman Foundation Archives available to the general public, former Pullman employees, and members of the Pullman community. It was then decided to add some of the more interesting photos from other collections holding Pullman material.

I am grateful to those who provided help and input as this project developed. William Kirchner and Michael Wolski were more than willing to share their vast knowledge of the community. Janice Helge was of invaluable assistance in editing and selecting the various images used in this book; it has been my pleasure to work with someone so intelligent and conscientious, a rare combination of virtues.

A salute to my friend Paul Petraitis, who patiently read and checked the photo captions and helped to identify some of the early photographers. A special thank you goes to Jay Hoppie, who spent many hours scanning the photographs for this book.

Cheers to another friend, Charles Gregersen, who provided not only drawings of some of the buildings but also much needed information on the architecture of the factory and community.

There are nameless others who offered up exotic bits of information about local characters, long deceased, and about the organization and operation of the Pullman Company. We should be especially grateful to those now deceased who, over the years, saved various company and personal photographs as well as the paperwork associated with a lifetime of living and/or working in the unique Chicago community known as Pullman.

INTRODUCTION

At the time the town of Pullman was begun in the early 1880s, the railroad industry in the United States had reached a very high level of importance. Due to the expansion and resulting demand for products related to the industry, George M. Pullman recognized the need to expand his car-building operations. When production at the Pullman factory commenced, the demand for more and better rail cars (passenger as well as freight) increased. This fact was in great part responsible for the growth rate experienced by the industry during the decade of the 1880s.

The town was constructed in the early 1880s by George M. Pullman as an expansion site for his railroad car-building operations, and to house the employees who would work there. The Calumet region offered both rail and water transportation facilities necessary for the operation of the business, and the decision to build there guaranteed Chicago's continuing role as the railroad center of the United States. The opening of the facilities also brought many persons to the area who were seeking employment, and the town became the focal point of the region's continued development and expansion. The town was annexed to the City of Chicago with the village of Hyde Park in 1889.

The town of Pullman has been called the first planned industrial community in the United States. From a planning perspective, then, the town served as a model for subsequent developments in which industry, housing, and public spaces were combined into a harmonious whole.

The Pullman Strike of 1894 also signaled a milestone—this time in the continuing development of the labor movement. The town served as a focal point for many of the actions surrounding this event.

George Pullman is most readily identified with the city of Chicago because of his decision to make the town of Pullman the site of the national headquarters of his railroad car-building operations. He was also active in many of Chicago's cultural and civic organizations (the Chicago Citizen's League, the Calumet Club, the Commercial Club, the Chicago Athenaeum, the Chicago Relief and Aid Society, the Chicago Musical Festival Association, and others) and held the offices of president, vice president, director, and counselor in many of these groups.

The town's architectural scale, visual continuity, compatible design characteristics, and integrity of materials distinguish it as having been planned within a framework of "total design." The elements of a number of architectural styles can be found (Richardsonian Romanesque, Queen Anne, Neo-Classic, etc.), but the blending of these elements with the overall form and function set the town apart as being unique.

The town, which was the work of 27-year-old architect Solon S. Beman and 37-year-old landscape architect Nathan F. Barrett, has been called the first planned industrial town in the United States. After becoming famous for his design of the company buildings and housing, and with the aid and assistance of George Pullman, Beman was commissioned to design a number of buildings in Chicago's downtown district (the Pullman Building, the Fine Arts Building, Grand Central Station, and others), as well as many residential structures, of which the Kimball House on South Prairie Avenue is the most prominent example.

7

Probably one of the most important features of the town from a technical standpoint was the amount of exhaustive planning that went into the project before actual construction began. The sewage system, water and gas distribution, grading, and site layout are a few examples of this work. The brick used in the construction of the buildings was fashioned from clay obtained through the dredging of Lake Calumet. Though the town's main function was of a utilitarian nature, aesthetics were not overlooked; the detailing of many of the buildings attests to this fact. The care that was taken in constructing the buildings was likewise significant, and the present condition of the structures bears this out. Having been started in 1880, it was also the largest work by an architect of the "Chicago School" up to that time. In short, the town represented innovations in a number of areas, all of which merged to form the unit.

The unique qualities, character, location, and coherence of the Pullman District establish it as a definite, bounded neighborhood and community within the city of Chicago. Its individual identity is assured and clearly defined by the Illinois Central Railroad/Metra Line right-of-way and industrial land uses, and it blends pleasingly with its surroundings to retain this identity in an urban environment. The similarity of the structures in their construction, materials, and details also serves to unify the district from a visual standpoint; the harmonious quality is apparent throughout. Each of the many structures within the district (Hotel Florence, administration building and Clock Tower, and others) is readily associated with the historic town.

Pullman, Illinois, was a dream, an experiment, a model, a business enterprise, and, for the most part, a success. A well-planned company town employing the most advanced methods of construction, landscaping, and sanitation, its physical aspects were universally acclaimed. The company-town concept in general, however, and the paternalistic management of this one in particular, drew praise from some, and condemnation from others. Whether George Pullman's motives were benevolent or malevolent, philanthropic or mercenary, they were a matter for public discussion not only throughout the country, but throughout the world. While economists, city planners, and businessmen unstintingly extolled the virtues of the town, the infant labor movement viewed it with mixed emotions. Although labor leaders at first commended George Pullman for providing his employees with better-than-average working conditions, excellent housing, fine public services, and good recreational facilities, they later came to disapprove of his monarchical rule over the company, the town, and the lives of his employees, who had no voice in company policy or town government.

A pleasant neighborhood on the southeast doorstep of Chicago, Pullman provides not only a historical and architectural link to the past, but a visual and spiritual relief from the central city's jam-packed conglomeration of structures running the entire spectrum, from posh high rise to abject slum.

Whatever the town of Pullman was in the past, it remains today a legacy of a bygone era that is important not only to the student of history, economics, or sociology, but also to a generation that has lost touch with the past. For the most part still intact, Pullman stands as a concrete, living study of orderly town planning, well-thought-out architectural scale and continuity, and life in a distinctive, cohesive urban community. Its past is important, but so is its future.

One

GEORGE M. PULLMAN

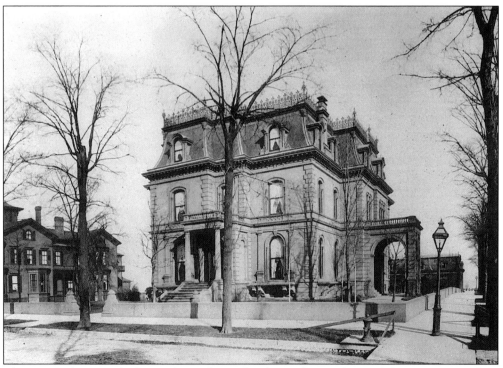

This 1885 photograph shows the Pullman family residence, designed by Henry S. Jaffray, located on the northeast corner of Prairie Avenue and Eighteenth Street, one of the very posh residential districts of the city. Neighbors on Prairie Avenue were the wealthy of the city including Marshall Field and Philip D. Armour. Between the mansion and the Illinois Central Railroad tracks was a private spur or siding connecting with the main line. Pullman had his private business car parked here when not in use. Evidence of the bed for the siding can still be seen today. (Courtesy of Chicago Historical Society.)

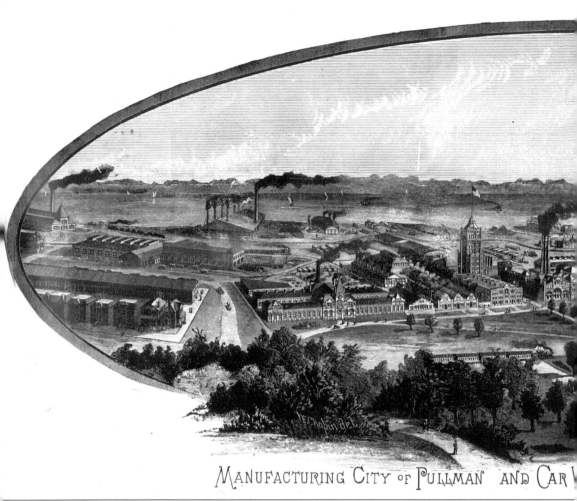

MANUFACTURING CITY OF PULLMAN AND CAR

This *Western Manufacturer* lithograph of the shops and residential areas of the company town was executed in advance of construction. The land was purchased secretly in 1879 to avoid the possibility of inflated land costs. The site was located about 15 miles south of Chicago.

While company housing was nothing new in the United States in 1880, this undertaking by George Pullman was the first such social experiment taking advantage of total planning. Pullman believed that by providing an environment superior to that available to the working

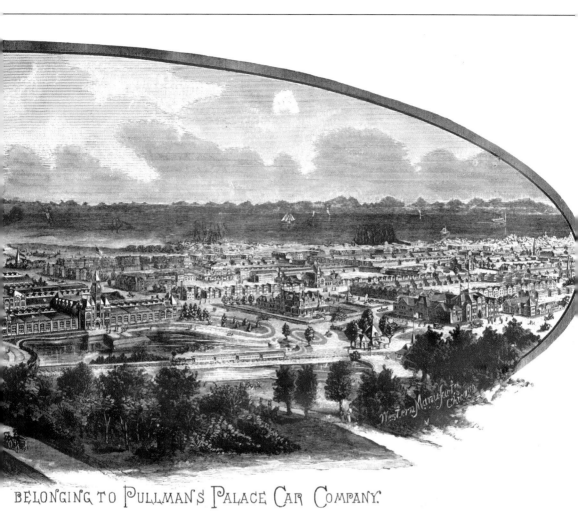

BELONGING TO PULLMAN'S PALACE CAR COMPANY.

class in any other city, he could avoid strikes, attract more skilled workers, and attain greater productivity due to the better health and morale of his employees.

The town included well-designed industrial buildings, a church, bank, hotel, two commercial structures, a variety of housing types, parks, and recreational and cultural facilities. The north boundary of the historic district is at 103rd Street, while the south boundary is at 115th Street. Cottage Grove Avenue is the west boundary and the east limit extended to Lake Calumet.

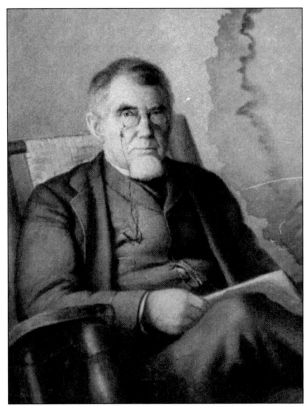

George Pullman was the third child born to James Lewis and Emily Caroline (Minton) Pullman in what is now Brocton, New York. After completing the fourth grade of school in 1845, he went to work in a general store for a salary of $45 per year. After three years at the store, he went to Albion, New York, to live with his family, who were now in the carpentry and cabinet-making business, where he became an apprentice cabinet-maker. Later his father, Lewis, entered the house-moving business. George helped in the business, taking it over after the death of his father in 1853.

In 1854 the New York legislature approved funds to widen the Erie Canal because the existing width delayed traffic during a period of economic expansion. Pullman contracted with the State of New York to move 20 or more buildings back from the right-of-way along the canal. This work lasted for about three years. In 1857 he moved to Chicago to expand his opportunities.

George Pullman's timing enabled him to take advantage of a booming large city. In 1859 he was awarded a contract to raise the five-story Matteson House at the northwest corner of Randolph and Dearborn 5 feet to street grade. His building-raising business was now secure for the next several years.

Profits from the building-moving business and a short and profitable stay in Colorado during the mining boom enabled him to devote time and capital to producing railroad sleeping cars. After several years of development, the business prospered and ultimately, because of the remarkable railroad expansion, became a major corporation in America.

The above portrait of George Pullman, created shortly before his death, hangs in the lobby of the Hotel Florence.

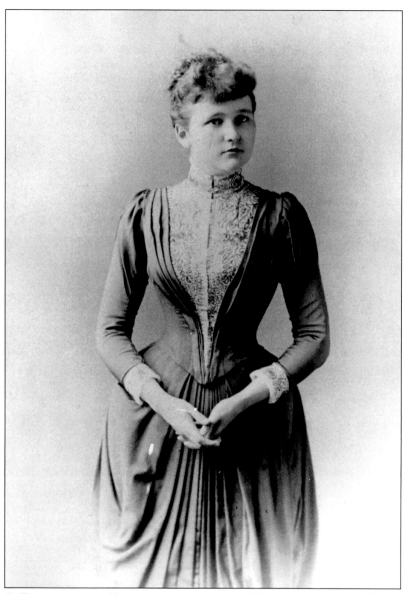

Florence Pullman is pictured here as a young woman. This photo was probably taken about the time of her marriage to Frank Lowden on April 29, 1896. Her father gave his consent to the marriage late in 1895. A contemporary newspaper account called the wedding "the most imposing and brilliant in all its appointments and details that has ever taken place in the city of Chicago." The article continues as follows: "The Pullman mansion was thrown completely open last evening, every apartment being beautified with a great wealth of plants, palms, vines, and flowers . . . All these decorations came from the conservatory adjoining and forming a part of the Pullman mansion . . ."

Four children were born to this union: George M. Pullman Lowden, who was an infant when his grandfather died; Florence, who married Dr. C. Phillip Miller; Harriet, who married Albert F. Madlener; and Francis, who married John B. Drake III.

Frank Lowden became governor of Illinois in 1917. George Pullman named the hotel and main street in his company town after Florence, his first-born child.

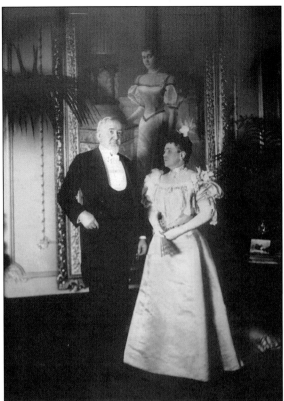

Mr. and Mrs. George M. Pullman are pictured here, c. 1884. The couple was married on June 13, 1867, in Chicago. Harriet "Hattie" Amelia Sanger Pullman was born in Chicago to Mary Catherine McKibben and James Y. Sanger, a builder who helped construct railroads in the Midwest. Children born to George and Harriet were Florence, Harriet, and twin sons George Mortimer Jr. and Walter Sanger.

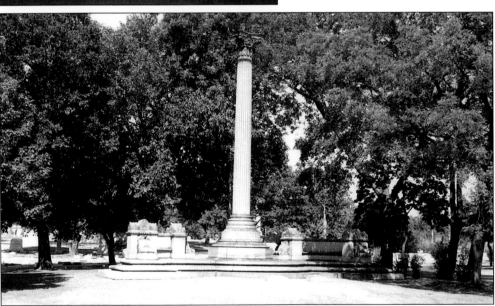

Here is the Pullman family grave marker, a simple Corinthian column designed by Solon S. Beman, in Chicago's Graceland Cemetery. Because of the unfavorable publicity that George Pullman received during and after the 1894 strike, his casket was covered with wood planking and steel rail before the final ground cover was put on the excavation. Also interred in this plot are his wife, Hattie, daughters Harriet and Florence, and other members of the family.

Two

Industrial Buildings, Passenger Cars, and Marine Division

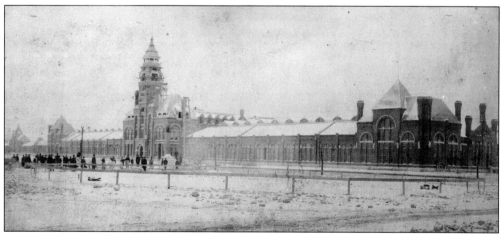

A winter scene in front of the administration building, with Lake Vista in the foreground, is shown in this photograph, c. 1880. The administration building was then under construction. This was to become one of the most beautiful industrial landscapes in America.

The manufacturing offices were to be located in this building along with the office of the plant manager. One floor of the building was dedicated to the engineering department. Other offices included the personnel department and the purchasing group.

Lake Vista was constructed with about three acres of surface. The earth removed during excavation of the lake was used to raise the elevation of the site of the flanking erection shops. The banks of Lake Vista would be beautifully landscaped with shrubs and flowers. Water from Lake Vista was used to condense the exhaust of the Corliss engine housed in an adjoining building. Lake Vista was filled around 1906, and Cottage Grove Avenue now passes through the once impressively landscaped area.

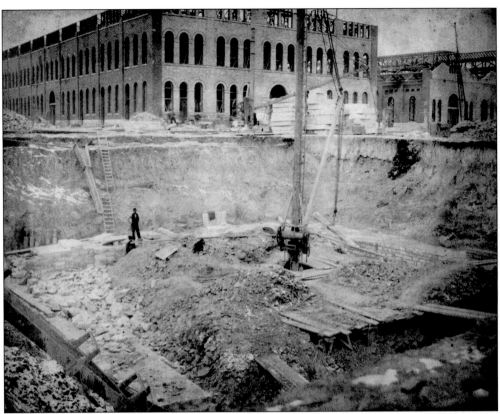

This is an 1881 construction photo of the excavation for the foundation of the water tower. (Courtesy of Art Institute of Chicago.)

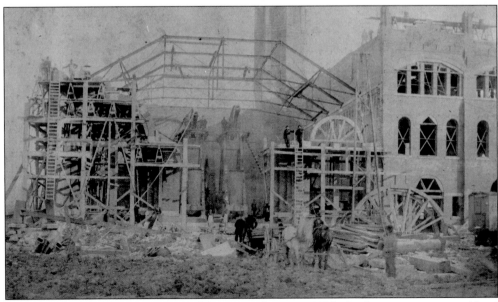

This photo shows the construction of the engine house in 1881. At the same time assembly of the great Corliss engine was underway. (Courtesy of Art Institute of Chicago.)

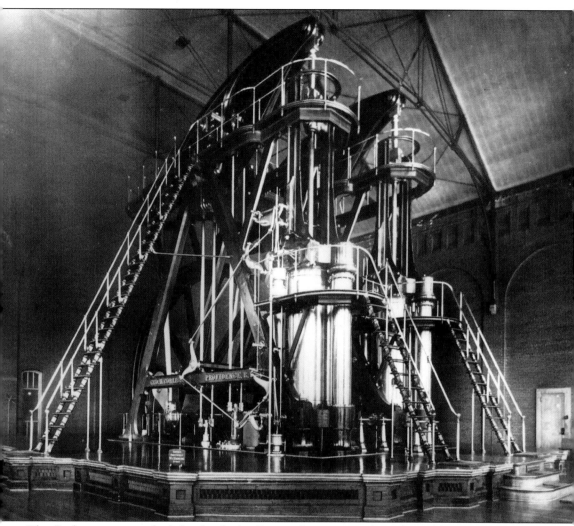

The Corliss engine was built by the Corliss Engine Company to drive the mechanical exhibits at the Philadelphia Centennial Exhibition of 1876. The Pullman Company purchased the 2,500-horsepower engine to drive a major portion of the production machinery in the Chicago plant. Pullman's daughter, Florence, opened the throttle valve to start the engine on April 5, 1881. The engine was housed in a building measuring 84 feet square. By 1893, the engine was driving 3,000 feet of main line shafting located 4 to 5 feet underground and 13,000 feet of overhead line shafting in the various buildings. The engine house was kept shining like a palace because of the large number of visitors. This colossal, 700-ton engine was scrapped in 1910 after the plant was electrified.

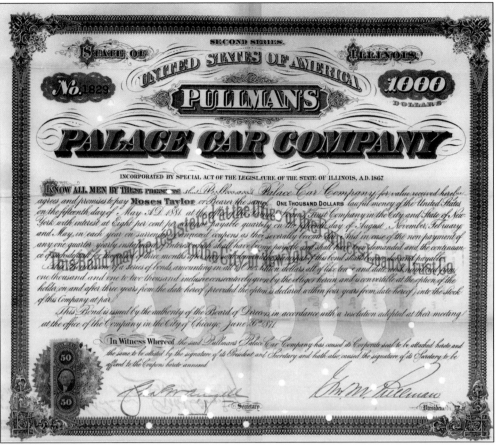

Here is a Pullman Company bond issued in 1881. The business of the Pullman Palace Car Company expanded along with the growth of the American economy. In the early 1880s it was considered among the largest and best corporations in the country with very strong and stable management. Its stock was among those that paid the best dividends.

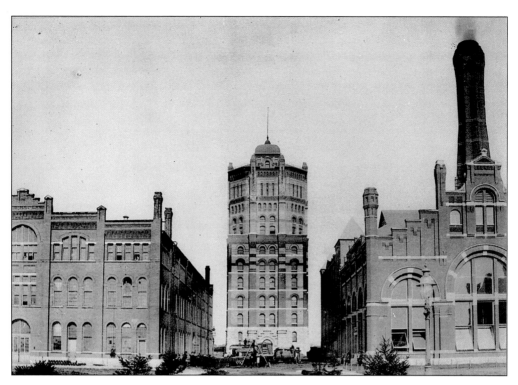

Pictured above is the west elevation of the water tower. The 530,000-gallon tank at the top of the brick structure was used to supply the fire protection sprinkler system for the factory and fire hydrants in the community. Below the 68-foot-square base of the tower was a 300,000-gallon holding tank for sanitary sewage from the community and factory. This was pumped three miles south to a 140-acre sewage farm, where it was distributed over the land as fertilizer. The height of the tower from grade to the roof was 195 feet. On the right is the Corliss engine house. On the left is the machine shop.

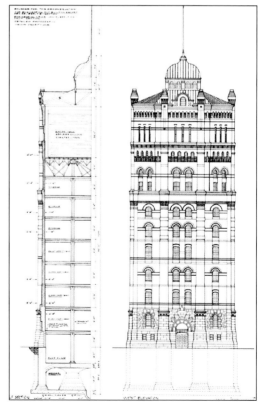

This is a contemporary drawing of a cross section of the water tower. The various floors of the tower were used for light manufacturing. In 1893 the electrical department had 26 employees, the glass department had 50 employees, and the fifth floor was occupied by a branch of the paint department. (Courtesy of Charles Gregersen, AIA.)

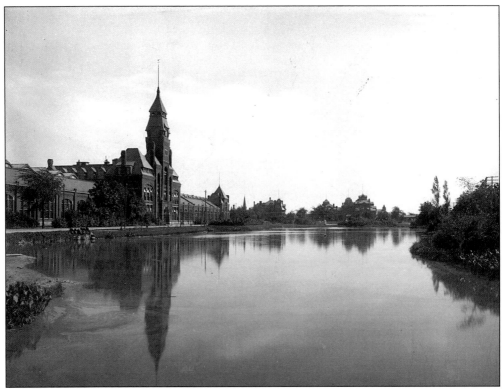

The administration building and erecting shops are shown on the left in 1887. Lake Vista, a decorative pond used to provide cooling water to condense the exhaust steam from the Corliss engine, is in the foreground. The photo, looking south, shows the Florence Hotel in the left background and the Arcade building in the center.

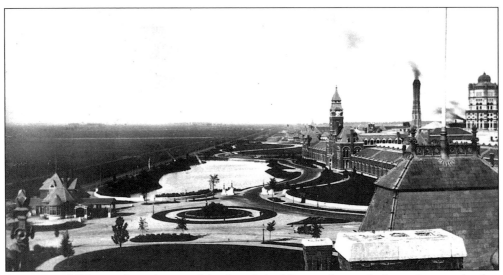

A stunning 1883 view from the top of the Arcade building to the north shows the open land to the west, the railroad depot in the lower left, and Lake Vista and the erection shops to the right of the depot. The building in the lower right is the Hotel Florence. (Photo by T.S. Johnson.)

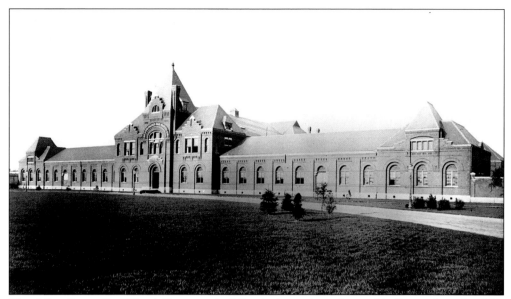

The Allen Paper Car Wheel Company building is shown here, located in line and north of the administration building. This factory made wheels for the Pullman sleeping cars. The two-story building measured 364 feet by 140 feet. The front of the building contained offices, and the rear was a foundry where wheel hubs were cast. The remainder of the building contained a machine shop, drying rooms, a pattern shop, blacksmith shop, and boiler room. Production of paper car wheels ended in 1897.

During Frank Leslie's 1877 tour of the United States, George Pullman is shown pointing to a paper car wheel used on one of his Detroit-built sleeping cars. This is from an illustration in *Frank Leslie's Illustrated Newspaper*, August 25, 1877. The paper car wheel, patented in 1869 by Richard Allen of Vermont, used circular paper compressed between metal plates extending from the cast-iron hub to the steel tire. Use of these wheels, in theory, provided a smooth ride for the passengers.

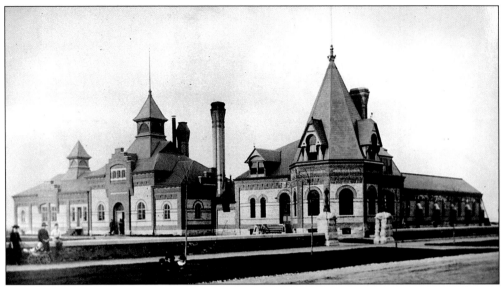

This is a rare photograph of the gas works building. The Pullman Company manufactured, using the Lowe process, their own fuel gas from coal. This supplied the needs of the factory and the residential buildings. The gas was stored for use in a conventional gas holder located at the back of the building shown here on the left side. George B. Burns was the gas works superintendent at the time that this photograph was taken in 1885. After the factory and community were connected to the local gas utility, the building was used as a brass shop.

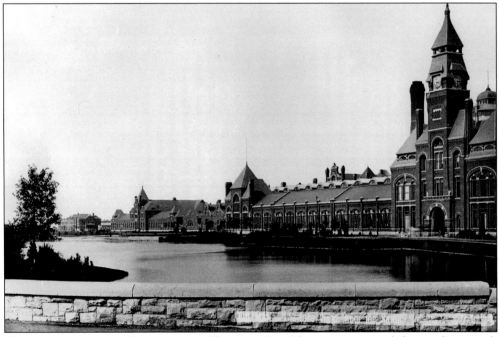

The administration building is pictured here c. 1890. The view is toward the northeast with Lake Vista in the foreground. The Allen Paper Car Wheel Company is just beyond the erecting shop. Beyond the Allen building is seen the housing in the north section of the Pullman community.

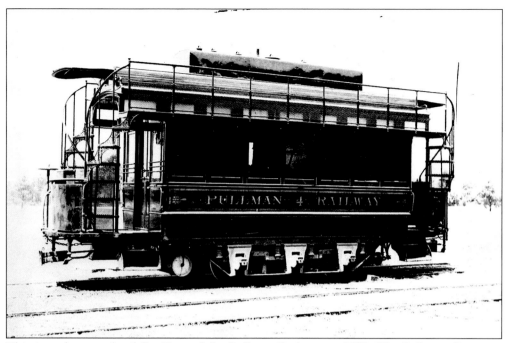

This is a photograph of Car Four of the Pullman Railway, c. 1889. The Pullman Company operated a local streetcar line which enabled them to also use the right-of-way to test their own production of streetcars. (Courtesy of Pullman Research Group.)

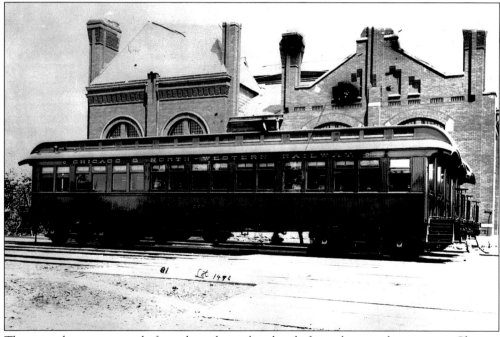

Three coaches constructed of wood are shown lined up before release to the customer, Chicago and Northwestern Railway, c. 1885.

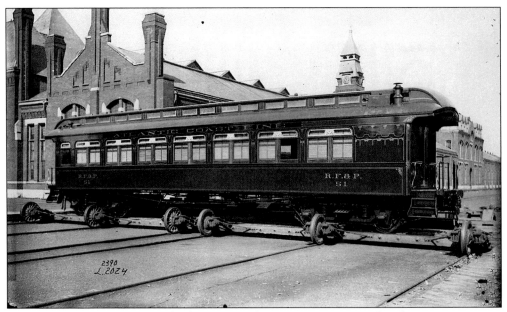

This 1890 builder's photograph shows an Atlantic Coast Line Railroad passenger car on the transfer table. The next production step will be preparation of the car for shipment to the customer.

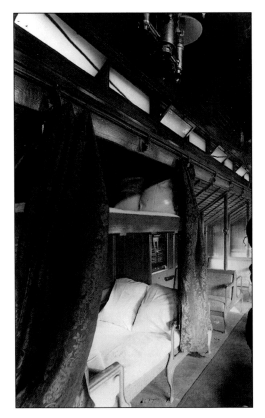

This undated interior view of a sleeping car is probably from the 1880s, as evidenced by the gas lighting suspended from the ceiling. The photo shows how the upper berths were lowered to make up both the upper and lower berths.

A 1904 interior view of the car *Paulina* is shown in this photograph.

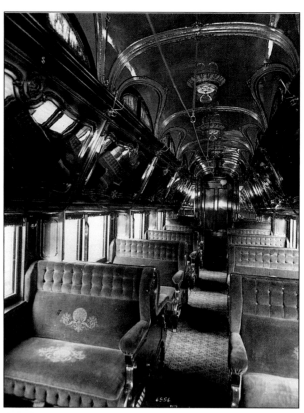

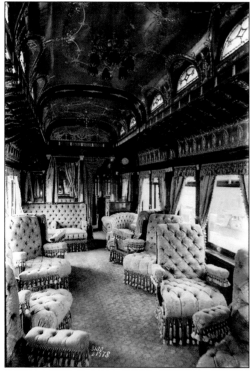

The Pullman Palace Car Company exhibited several different passenger cars at the World's Colombian Exposition in 1893. This photograph shows the elegant interior of parlor car *Santa Maria*.

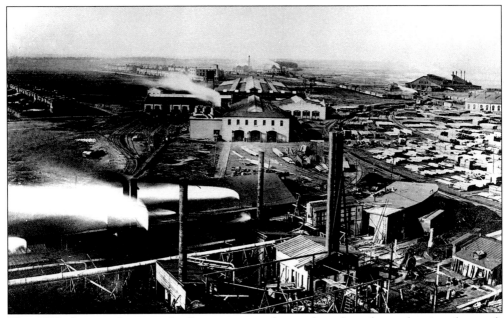

This 1892 photograph gives a bird's-eye view to the north and northeast showing the north half of Pullman.

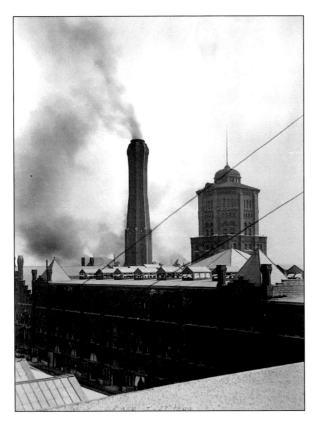

This 8:00 a.m. view over the wood machine shop roof looking toward the water tower was taken on July 27, 1899. The Corliss engine house is to the left. As with most late-19th-century chimneys, the architectural detail is quite elaborate.

In remembrance of the assassination of President William McKinley in 1901, the Pullman Company's main entrance on 111th Street (Florence Boulevard) is draped with bunting.

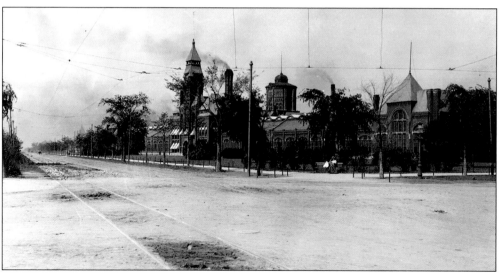

This photograph shows the shops from the southwest, *c.* 1907. Note the streetcar tracks on Cottage Grove Avenue (formerly Pullman Boulevard). Lake Vista, which had been in this location, was filled in the year before. With the start of plant electrification, the Corliss engine used a different source of cooling for the exhaust steam, making the water in the pond unnecessary. Elimination of the pond would simplify ground maintenance and make it possible for Cottage Grove Avenue (Pullman Boulevard) to extend south without interruption to 115th Street.

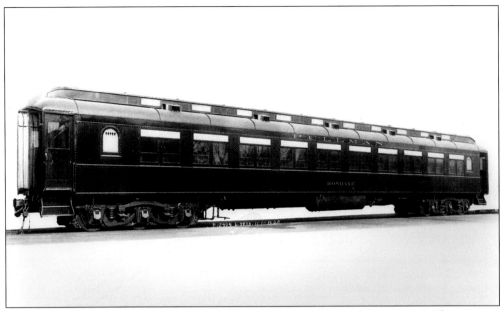

The Pullman-built sleeper *Rondaxe* was constructed in the Chicago shops in 1910. This was one of the first steel cars. Wood passenger car construction had been the standard up to this time. Because the steel cars were safer than the wood design, most of the railroads specified steel as the preferred material from then on.

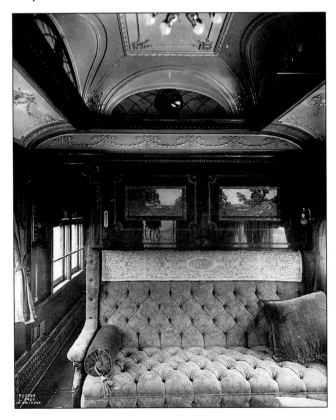

This is a builder's photograph of the car *Loretto*, which was completed in 1917.

We see a nice view of the water tower in this photograph taken in the 1920s.

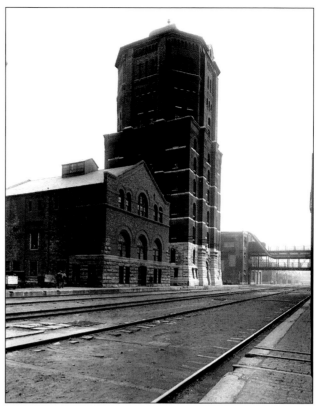

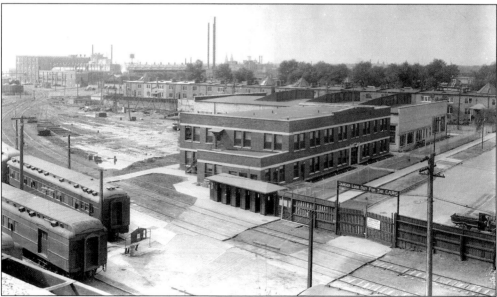

This 1920s photo shows the Calumet Shops, located east of the community between 111th and 115th Streets. This was one of the regional shops in the United States, where Pullman-owned cars came for restoration and repair. This was the site of the old streetcar shops which were established in 1886 under the direction of Charles Pullman, younger brother of George. During 1893 the streetcar shops employed 400 workers. (Courtesy of Chicago Historical Society.)

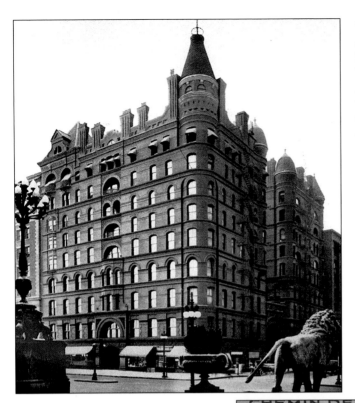

The Pullman Company office building designed by architect Solon S. Beman, at Michigan Avenue and Adams Street, was constructed in 1884 across the street from the Art Institute. This was where George Pullman and the executive officers of the Pullman Company were located. The upper floors contained some of the more fashionable apartments in Chicago. It also contained the Tip Top Inn, once frequented by George M. Cohan. The building was demolished in 1956. (Courtesy of South Suburban Genealogical and Historical Society.)

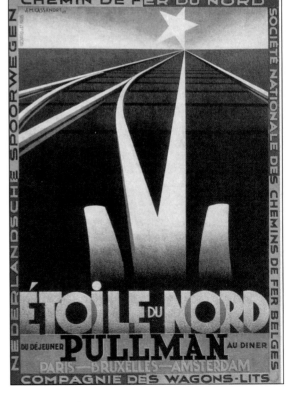

The Pullman Company was only partially successful in getting any of the European sleeping car construction business. The company did build a few cars for English railroads. This 1930s poster, used to advertise the *Étoile du Nord* train, indicates the importance of the Pullman name in European railroading.

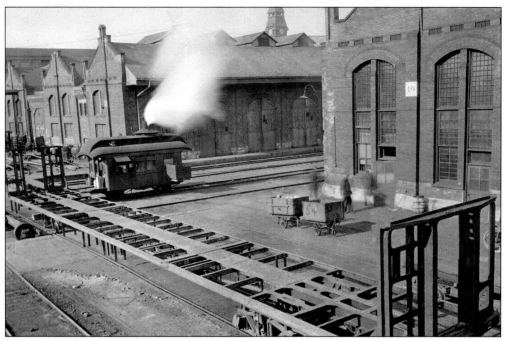

In 1929 the original donkey engine was still moving cars on the transfer table between the erecting shops for the various production operations.

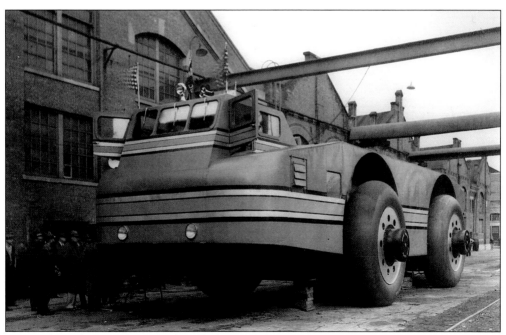

In October of 1939, this vehicle rolled out of the 111th Street shops bound ultimately for Antarctica, to be used for the third expedition headed by Rear Admiral Richard E. Byrd. The vehicle was 55 feet and 8 inches long, 19 feet and 10.5 inches wide, and 16 feet high. The design of the vehicle was such that it sank in the snow shortly after it was unloaded from the ship. Today the Snow Cruiser is probably still under the Antarctic snow and ice.

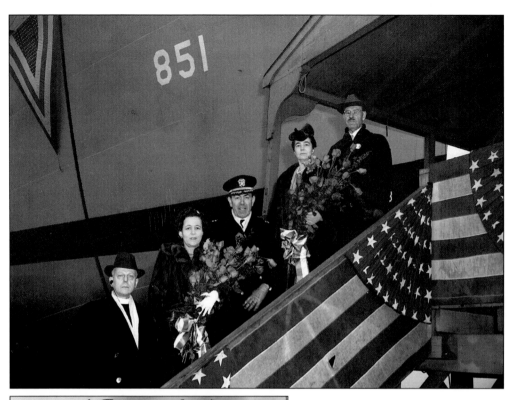

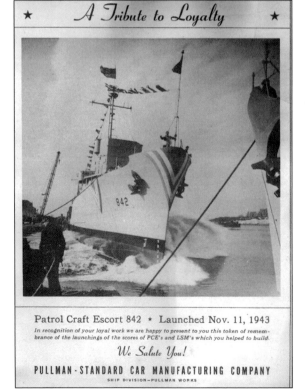

Harriet Lowden Madlener and Florence Lowden Miller were with the commissioning party for the launching of Navy patrol craft Number 851 on February 22, 1944. George Willis, the last principal of the Pullman Free School of Manual Training, is at the far right on the stairway. (Courtesy of George R. Caruso.)

The Ship Division of Pullman Standard was located at 130th Street on Lake Calumet. This facility, southeast of the main plant, produced patrol craft for the United States Navy during World War II. This brochure was to commemorate the launching of one of their ships. The Ship Division produced patrol craft and 44 landing craft for the Navy. (Courtesy of Nadine Kruger.)

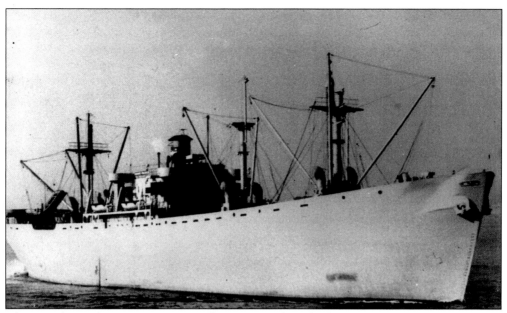

This vessel was the SS *George M. Pullman*. It was launched in April of 1943 by the Joshua Hendy Ironworks, Sunnyvale, California, and was cut up for scrap in Japan in 1963. During World War II over 2,700 Liberty Ships were constructed to carry war material to various fronts. This was the largest shipbuilding program in history and all were named after famous deceased Americans.

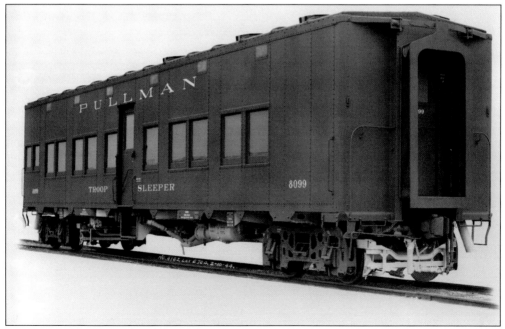

During World War II the demand for cars to transport troops exceeded the existing supply of passenger cars, so two lots of 1,200 cars each were produced by Pullman Standard for the Defense Plant Corporation. Pullman was awarded the contract to operate the troop sleepers. A Pullman porter was assigned to each car.

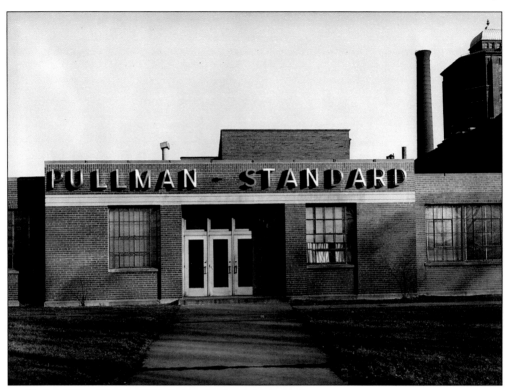

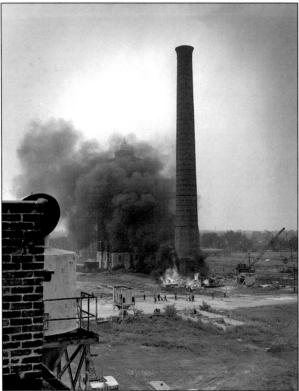

Prior to World War II Pullman Standard built a new engineering center, which is shown here with the water tower in the background. Today the Sherwin-Williams Company operates a research laboratory at this location. This building is located partially on the site of the old Allen Paper Car Wheel Company on Cottage Grove (Pullman) Avenue.

In 1957 Pullman Standard was preparing to sell off its property at the 111th Street shops. Preparing for this, a contract was let for demolition of the power plant chimney, located south of the water tower. A fire was started at the base of the chimney and was designed to topple the structure. This fire accidentally spread to the water tower and the damage was such that the water tower building had to be demolished.

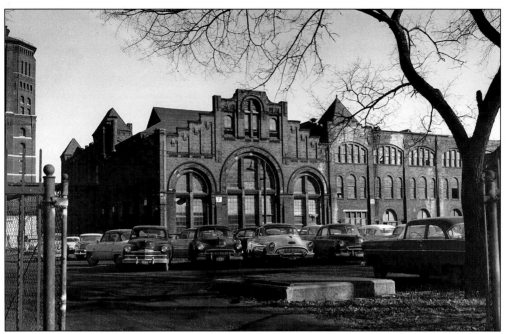

The water tower is to the left in this 1950s photo. The Corliss engine house is on the right. Note that the engine house was altered very little over the years. To the right of the engine house is the original wood machine shop.

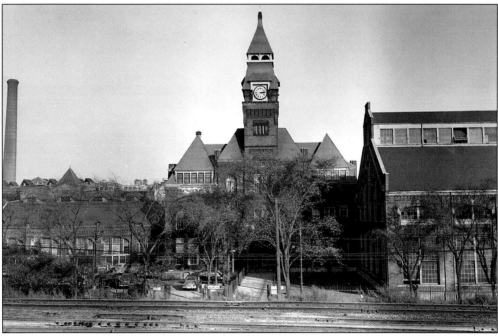

From the platform of the 111th Street Illinois Central Railroad (now Metra) commuter station, one had a nice view of the administration building in the mid-1950s. The 1909 revision to the south wing of the erecting shop is to the right of the clock tower building. This enlargement of the shop was necessary to accommodate the change-over from wood to steel car construction.

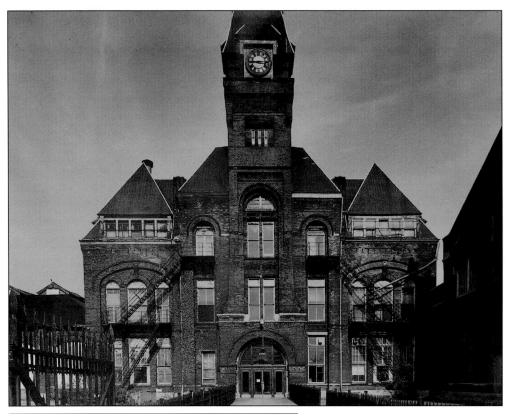

The administration and clock tower building still stands today at 111th Street and Cottage Grove Avenue as one of the most interesting ones in the shop area. This 1960s photo shows the decline in the building that occurred over the years.

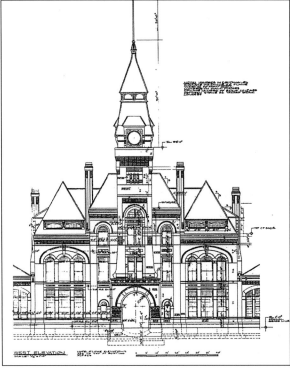

This is a contemporary drawing of the administration building. Note that in the previous photo the arched windows on either side of the main entrance have been replaced by rectangular openings. (Courtesy of Charles Gregersen, AIA.)

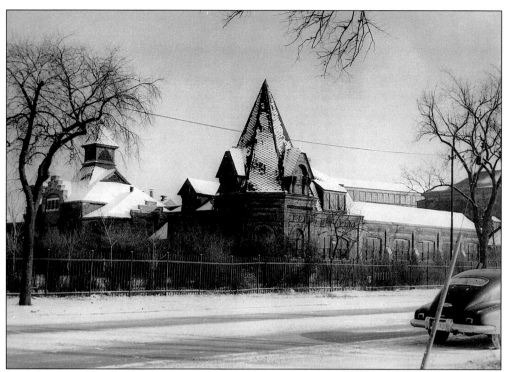

In 1880, this building was the gas house located on 111th Street. The building was converted to a brass shop after the plant and residential gas systems were connected to the local utility. This building was demolished in the 1960s.

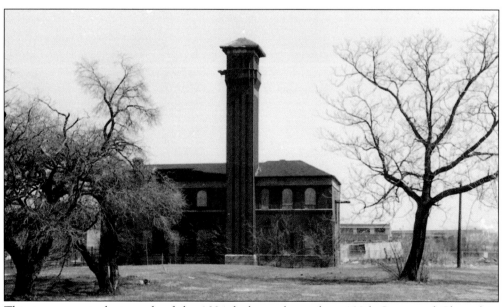

This is a current photograph of the 1894 firehouse located on 108th Street and Champlain Avenue. The building is used for storage today by the Sherwin-Williams Company. At one time the Chicago Fire Department used the building. It is the last remaining firehouse in Chicago with a watch/hose-drying tower.

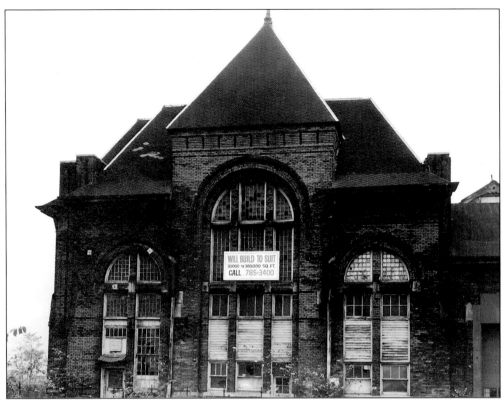

By the time this 1970s photograph of the erecting shop was taken, Pullman Standard was completely out of the original shop complex. This photo shows that even after 90 years of service the old building still had a few more good years.

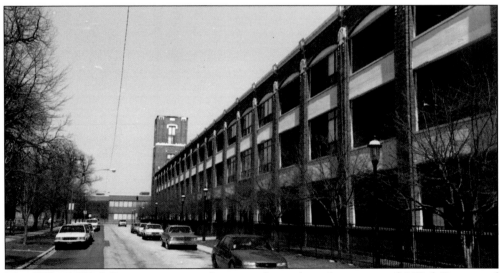

The "Wheel Works" apartment complex, now located at the corner of 103rd Street and Maryland, was photographed in 1994. This 1918 building was constructed by Pullman for the manufacture of automobile bodies for the Packard Motor Car Company. The contract lasted from 1919 until about 1923. It was converted to an apartment building in the 1980s.

Three

RESIDENTIAL BUILDINGS

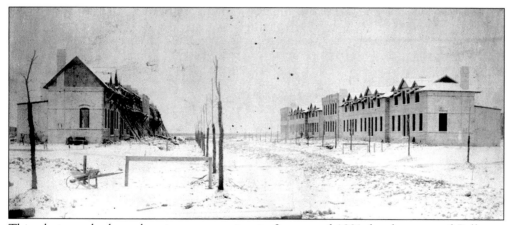

This photograph shows housing construction in January of 1881 for the town of Pullman. The view is looking south on Champlain (Stevenson) Avenue. Mrs. Duane Doty stated that "Mornings and evenings trains of cars carried the laborers and mechanics to and from Chicago." (Courtesy of Art Institute of Chicago.)

Mr. Edwin A. Benson, a foreman transferred from the Detroit shops, was the first householder to move into the new town of Pullman. His family, consisting of his wife, a child, and his wife's niece, Miss Floro Hill, moved into house Number 101 on Watt (St. Lawrence) Avenue on January 1, 1881. The house, situated at the north end of Watt Avenue, was nearly completed. March of the same year saw 57 residents in the community, and two years later the population was 4,512. By July 1885, the population was 8,603 persons and in 1890, 10,680 people were living in Pullman. The population probably peaked in 1892 when an enumeration indicated that 14,702 people resided in and around the town of Pullman. Note that these numbers include both the residential area north of the shops and the area south of the factory complex. This would cover the area from about 104th to 115th Streets. Of the total number of residents enumerated on August 1, 1892, 11,702 men, women, and children lived in the Pullman community.

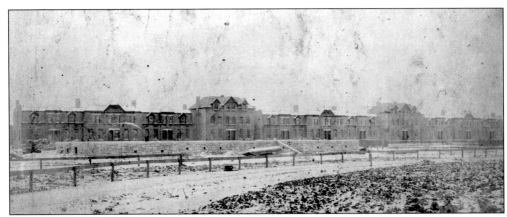

This 1881 construction view is from the foundation of the hotel site looking at the residential construction on St. Lawrence (Watt) Avenue. (Courtesy of Art Institute of Chicago.)

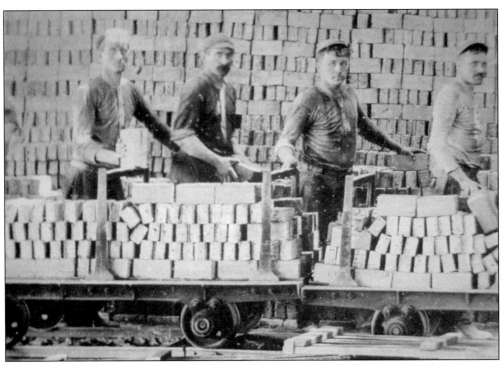

While construction was in progress, the Pullman Company brickyards south of 115th Street were in full production. The clay used to supply these brickyards was dredged from Lake Calumet. This operation was active at least until 1898.

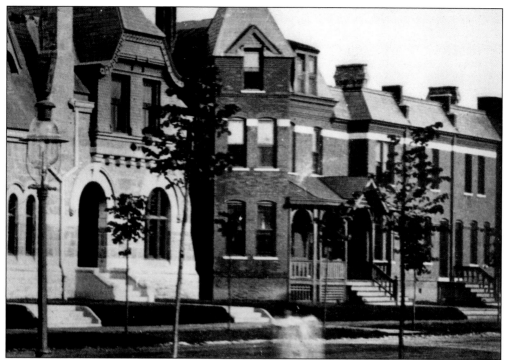

This is a view of the 11200 block of St. Lawrence (Watt) Avenue in the late 1880s looking south. On the left is the facade of the Greenstone Church. The church was dedicated on December 11, 1882, by the brother of George Pullman, the Reverend James M. Pullman. The building adjacent to the church was to become, *c.* 1910, a hospital, and today it is in use as apartments. This building to the south was used in the early 1990s during the filming of the movie, *The Fugitive*.

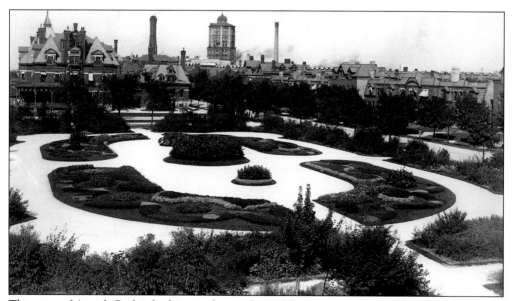

This view of Arcade Park is looking to the northeast. The photograph was taken from the roof of the Arcade building. The hotel, residential buildings, and water tower are in the background.

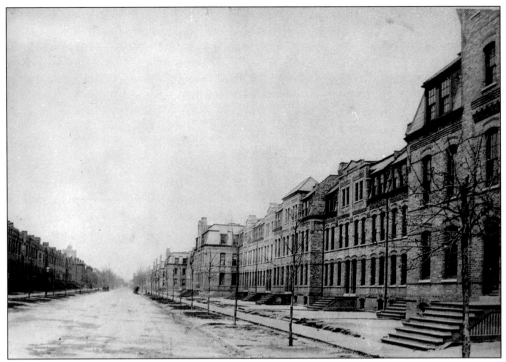

This photograph is of Langley (Fulton) Avenue looking north from 113th Street. These three-story buildings have one apartment on each floor. Each apartment contained four rooms.

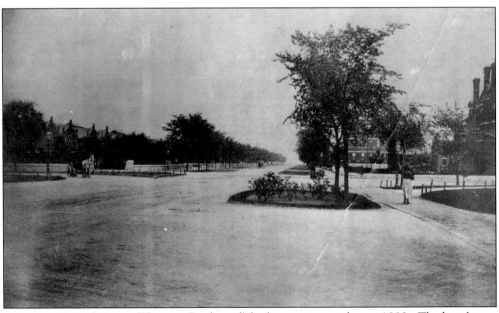

This view of 111th Street (Florence Boulevard) looking east was taken c. 1880s. The hotel is on the right and factory shops on the left.

This is a photograph of the house on the southeast corner of 111th Street (Florence Boulevard) and Champlain (Stevenson) Avenue. This was the home of band conductor J.W. Hostrawser. It was later to become, with an extension built on the rear, a speakeasy (or "blind pig") during the Prohibition era. Two 500-gallon concrete tanks remain in the basement, a reminder of the mixing process used to create a common Prohibition-era beverage. Note the slate roof and chimney detailing. (Courtesy of Pullman Research Group.)

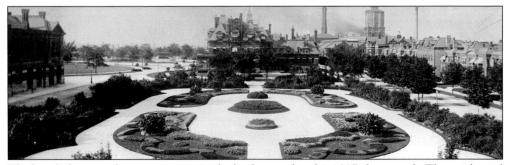

The hotel, shops, and water tower are in the background in this 1887 photograph. The residential buildings are on the right side of the formal garden and the Arcade is on the left.

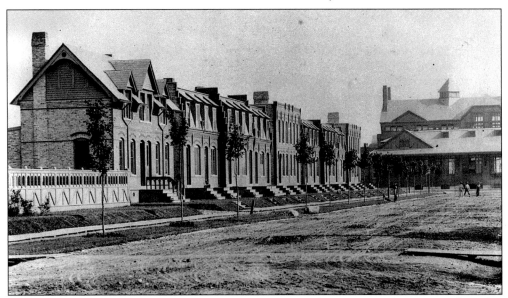

This is a view of Champlain (Stevenson) Avenue in 1886 looking toward the original Market Hall. Wooden sidewalks are evident and the street has yet to be paved. The house on the immediate left was demolished in 1960. Pullman building lots varied in width from 14 to 24 feet; depth of houses varied from 30 to 50 feet. (Courtesy of Pullman Research Group.)

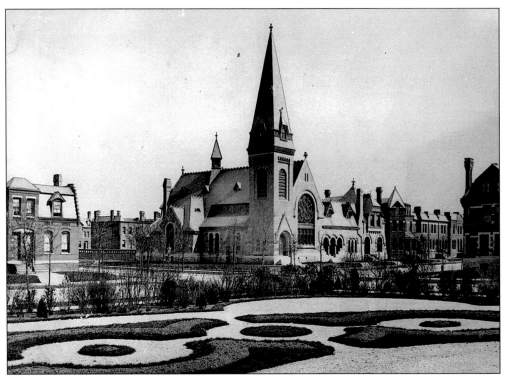

Here is a view of Arcade Park looking southeast toward the Greenstone Church. This photograph was taken from the park. The famous Pullman Marching Band of 60 performers gave weekly concerts here in the summertime.

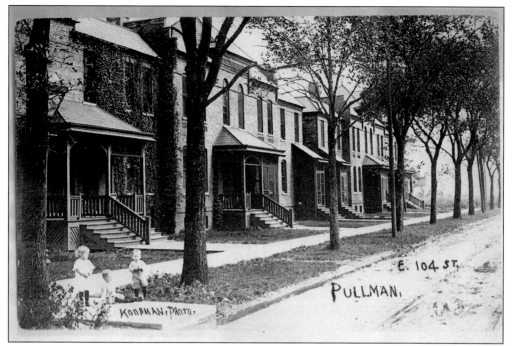

This 1893 Koopman postcard shows the houses on 104th Street just east of Corliss Avenue that were demolished to make way for Corliss High School. Corliss Avenue was named for George Corliss (1817–1888), who patented the Corliss engine in 1848. Today this street maintains the same name, not being changed by the renaming of streets after the community was annexed to Chicago in 1889. (Courtesy of Pullman Research Group.)

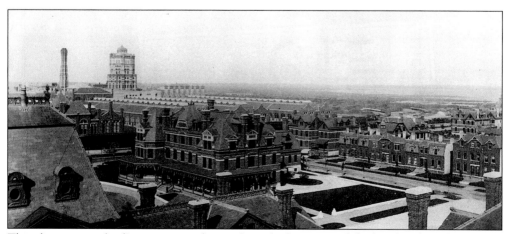

This photo gives a bird's-eye view to the northeast looking toward the hotel and residential area on Watt (St. Lawrence) Avenue. (Photo by T.S. Johnson in 1883.)

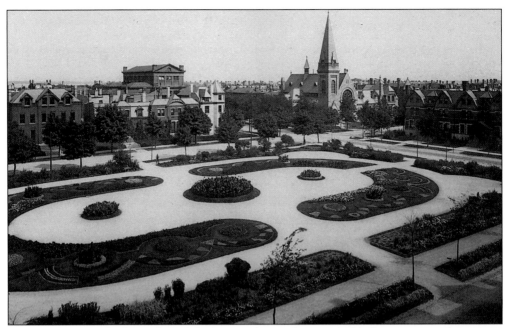

This is a photograph of Arcade Park looking to the southeast in 1898. Supervisors and managers lived in the houses surrounding the park. In the right background is the Greenstone Church, located on the corner of St. Lawrence (Watt) Avenue and 112th Street. Today this church is the Pullman United Methodist Church.

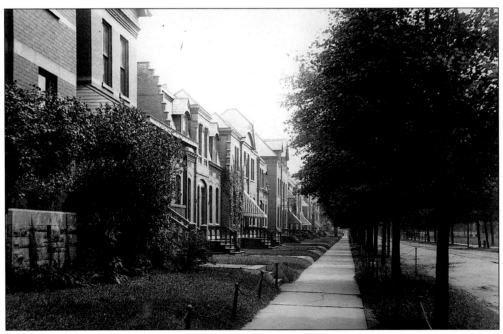

Pictured here is a view of St. Lawrence (Watt) Avenue in 1896 looking south from 111th Street (Florence Boulevard). The window awnings shown were installed and maintained by the company. The second building from the left was originally 101 Watt Avenue. E.A. Benson, the first householder in the community, moved into this building on January 1, 1881.

This drawing shows the elevation and plan of some of the housing units that were available. These designs are located on St. Lawrence (Watt) Avenue.

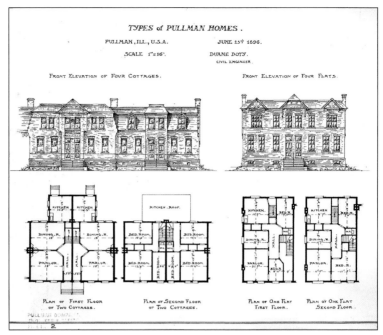

TYPES of PULLMAN HOMES.

PULLMAN, ILL., U.S.A. JUNE 25th 1896.

SCALE 1"=16'. DUANE DOTY.
CIVIL ENGINEER

FRONT ELEVATION OF FOUR COTTAGES. FRONT ELEVATION OF FOUR FLATS.

PLAN OF FIRST FLOOR OF TWO COTTAGES. PLAN OF SECOND FLOOR OF TWO COTTAGES. PLAN OF ONE FLAT FIRST FLOOR. PLAN OF ONE FLAT SECOND FLOOR.

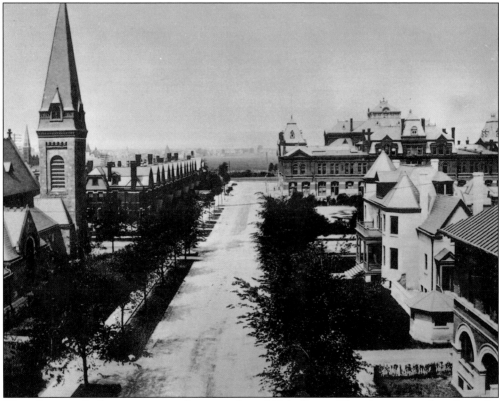

This photograph shows a view to the west along 112th Street. The photo was taken from the top of Market Hall c. 1896. On the left is the Greenstone Church, while the right foreground shows the white Graystone Mansion. The Arcade building is in the right background.

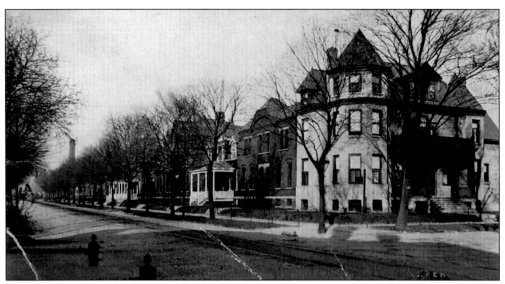

This postcard view is looking north on St. Lawrence (Watt) Avenue. The Graystone Mansion, built in 1893, is on the northeast corner. Note the streetcar tracks. Streetcars came south on Cottage Grove (Pullman) Avenue and looped around at 115th Street to go north on St. Lawrence, turn west on 111th Street, and turn at Cottage Grove Avenue to return north toward 95th Street.

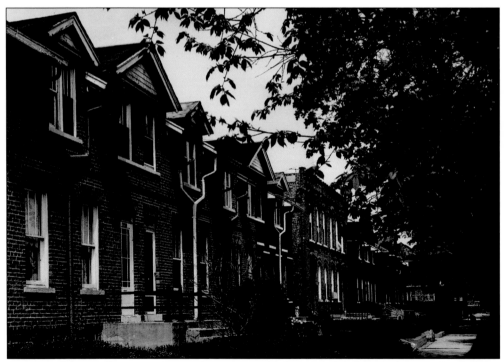

A photo of the row houses on Champlain Avenue looking north to 111th Street is shown here. The last house at 111th Street was the house of Dr. McLean. McLean's house was strategically located, being directly across from the main plant gate. This location made it convenient for injured workers to receive treatment as soon as possible.

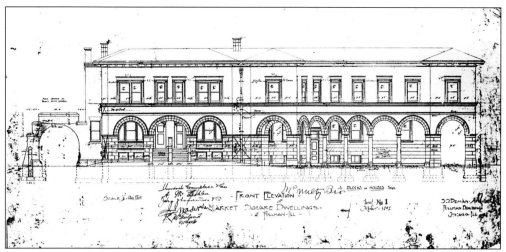

These plans were drawn by the office of S.S. Beman in 1892 for the new circle buildings to be constructed around Market Hall. (Courtesy of Art Institute of Chicago.)

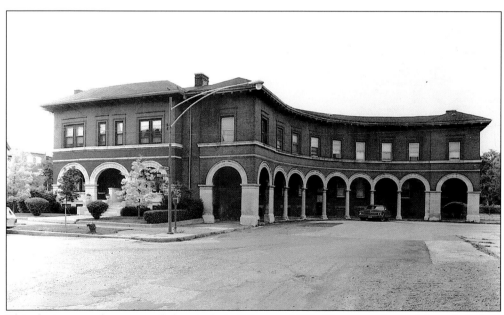

This depicts another view of the circle building *c.* 1970. There are four of these buildings around the Market Hall. These circle buildings were constructed in 1893 for Pullman's guests attending the World's Colombian Exposition. Later a few of the company engineers lived in the apartments. There are two apartments on the top floor and one apartment on the first floor. (Courtesy of Charles Simmons.)

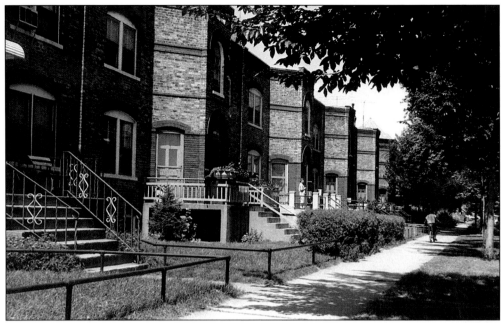

This photograph of Champlain (Stevenson) Avenue shows the 11400 block. These buildings are known as "bay front" apartments. Two apartments are on the first floor and two are on the second or top floor. Opening off the hallway on the first floor were four doors, each with a toilet, for the tenants. Today most of these "water closets" have been replaced by modern facilities.

A modern view of one of the skilled mechanics' houses located on St. Lawrence Avenue is shown here. This house, owned by Dr. and Mrs. A. Brislen, was open for the 1981 annual Pullman House Tour. These house tours, scheduled for the second weekend in October, feature six to eight homes open to the public. Profits from the house tours are used for various restoration and maintenance projects in the community. (Courtesy of Paul Petraitis.)

A Pullman parlor is decorated for Christmas in this photograph taken at 11107 St. Lawrence Avenue. William Kirchner's house was open for the 1996 Candlelight House Walk. Each Christmas season these tours give the public an opportunity to see the various house interiors.

The hallway and stairs to the second floor in the house, owned by L. Kris Thomsen, at 623 East 111th Street are shown here. This building was once owned by Dr. McLean.

This photo shows the interior of a building owned by Eugene Carollo on East 112th Street. This house was on exhibit during the 1982 annual house tour. (Courtesy of Paul Petraitis.)

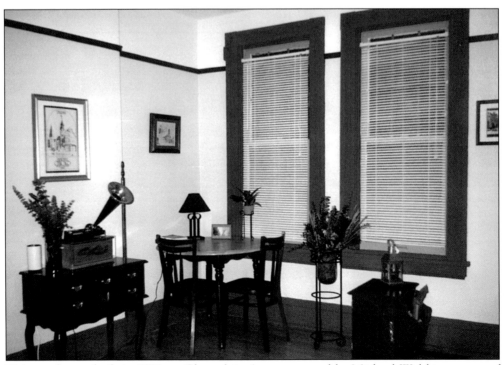

This row house, built in 1881 on Champlain Avenue, owned by Michael Wolski, was one of the homes open during the 1997 house tour. This is a good example of interior restoration. Any exterior building work requires approval by the Chicago Landmarks Commission.

Four

THE PEOPLE OF PULLMAN

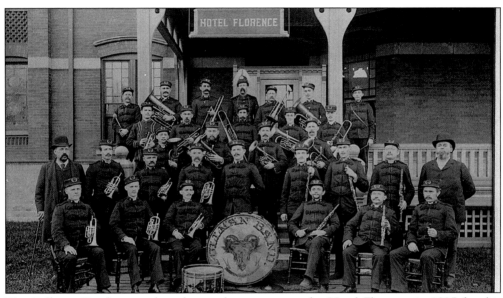

The Pullman Band is posed at the north entrance to the Hotel Florence in 1885 for this photograph. The band conductor, J.F. Hostrawser, is in the second row center. The works manager, H.H. Sessions, is in the second row left holding a cane. As listed on the back of the photograph, the members are, from left to right, as follows: (front row) Mr. Kiuze, Mr. E.R. Curtis, Nick Smauch, John Kries, Mr. Jones, and Jacob Kundson; (second row) Mr. Sessions, Mr. Bates, Mr. McCann, Jacob Hostrawser, Arthur Dingle, Joseph Speck, Mr. Tedliker, and Mr. Rapp; (third row) unknown, David Lowe, John Chadwick, and Ed Butcher; (fourth row) unknown, unknown, John Snyders, and Charles Rutan; (fifth row) Mr. Varner, John Hostrawser, Joe Brenheiser, Harry Pean, unknown, Samuel Gall, and Ernie Venning. The Pullman Band had a national reputation as one of the finest bands in the state.

Looking at the surnames of the band members, it is of interest to analyze the ethnic make-up of Pullman wage-earners. The following summarizes the birthplace of 6,324 wage-earners in 1892: 1,796 American-born workers; 1,422 of Scandinavian birth; 824 of German heritage; 796 British-born; 753 were Dutch; 402 were Irish; 170 were from Belgium, France, Italy, Spain, or Switzerland; and 161 were from either Asia, Africa, the East Indies, Hungary, Mexico, Poland, Russia, or Greece. "Eight hundred and forty-nine of these wage-earners owned their own homes in this immediate neighborhood," according to *The Town of Pullman Illustrated.*

Town and shop architect Solon S. Beman and landscape architect Nathan F. Barrett were photographed by Lake Vista, *c.* 1885. The Hotel Florence, Arcade building, and railroad depot are in the background.

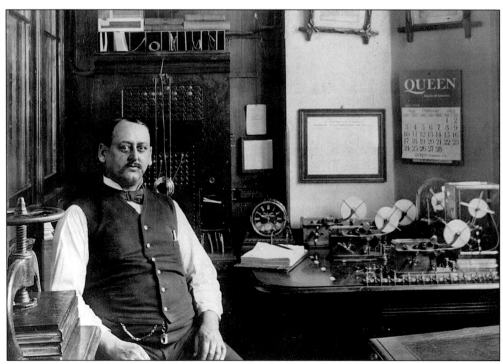

Joseph Vogt organized the Pullman Fire Department in 1881. He was the supervisor of the firemen and watchmen until 1915. This 1895 view shows him at his desk in the administration building. Joseph died in 1916 while living at 11117 Champlain Avenue.

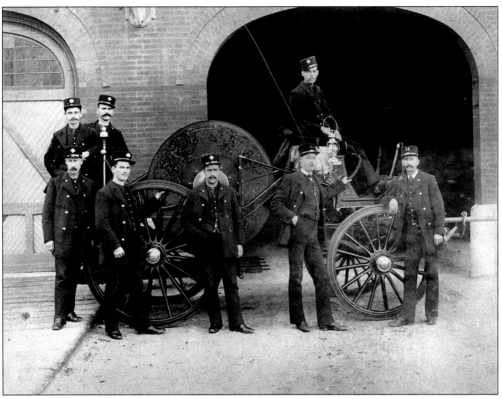

The hose cart appears to be well-manned in front of the stables. Note the edge of a white horse head between the door arches.

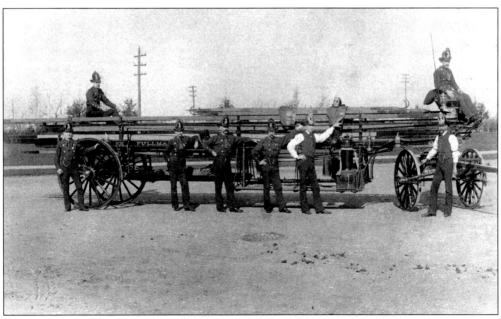

The hook and ladder firemen are posed beside the stables building, c. 1893. There were nine firemen in 1893.

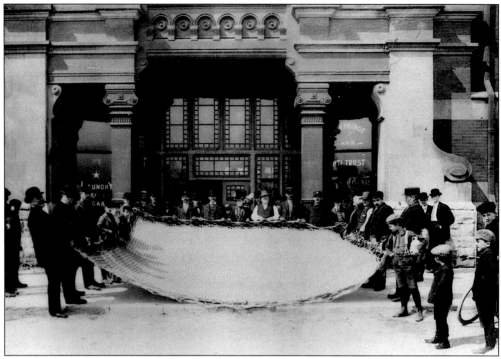

The Pullman fire brigade is demonstrating their safety net at the Arcade building, c. 1885.

This postcard is a view of Champlain (Stevenson) Avenue. The house on the left was the residence of J. Hostrawser, the Pullman Band conductor. Legend has it that John Philip Sousa stayed here while he was guest conductor of the Pullman Band. Note the gas lighting fixture used for street lighting at that time. The men are walking south from the main factory gate.

The Company of Yourself and Ladies is Requested

—AT THE—

INITIAL DANCE

—OF THE—

PULLMAN AMUSEMENT CLUB,

AT THE HOTEL FLORENCE,

On Thanksgiving Eve., Nov. 28, 1885.

R. S. V. P. _By Order of the Ladies Committee._

Hopkins

A dance card for the initial dance of the Pullman Amusement Club at the Hotel Florence, November 28, 1885, is shown here. It is likely the "Ladies Committee" was made up of wives of Pullman Company supervisors. The card is signed by John Hopkins, who was an officer of the Pullman Company. Later Hopkins was to break with George Pullman over a policy matter, and it is ironic that he was the mayor of Chicago during the Pullman Strike of 1894.

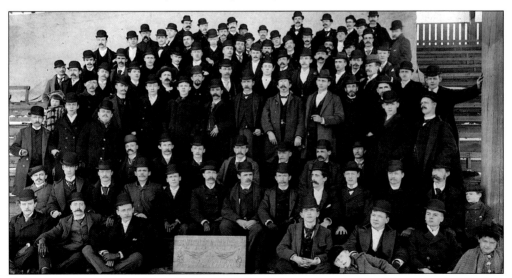

Pullman woodcarvers are shown here in an undated photo taken on the athletic island while they were attending a picnic. The artificial island was built near the end of 111th Street (Florence Boulevard) in Lake Calumet and was used for athletic and aquatic sports. It had grandstands, boathouses, and a course for foot races, walking matches, etc. on a 10-acre playground. All kinds of athletic sports and exercises were held there. Public games were regular events, and annual regattas were held. Valuable medals were awarded to the winners.

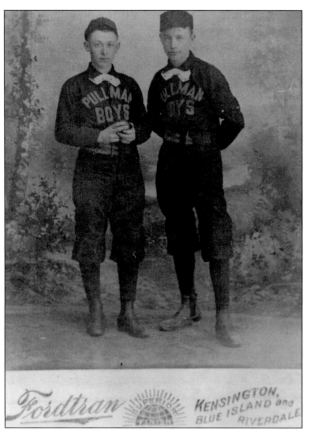

Edward Acton, 19 years old, and George Kruntze, 18 years old, were two of the "Pullman Boys" who played on the baseball team. The photograph is dated July 10, 1892.

The "Pullman Boys" team posed for this photo at the start of the softball season in Arcade Park in 1887. The company encouraged and supported the participation of the employees in a variety of cultural and sporting activities; these included cricket, bicycle racing, football, gymnastics, orchestra, band, singing societies, whist, etc.

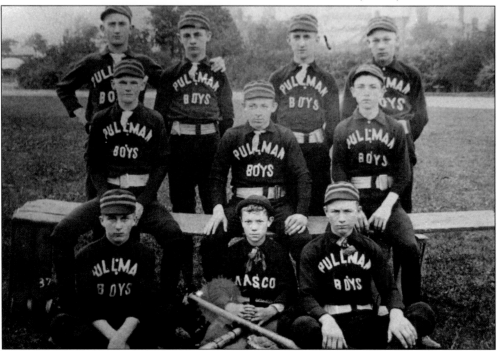

This is a *c.* 1890 photo of two unidentified families at, from left to right, 304, 302, and 300 Morse Avenue. Today these houses are 11304, 11302, and 11300 Forrestville Avenue. It is likely that this photo was taken by company photographer James P. van Vorst. (Courtesy of Chicago Historical Society.)

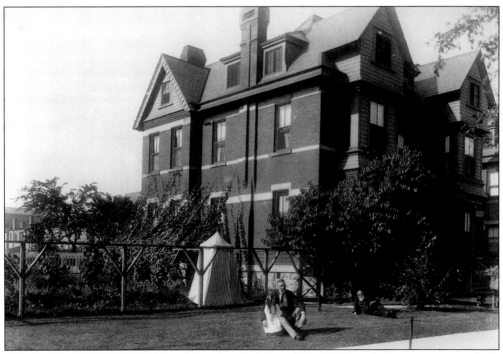

Number Seven Florence Boulevard was the residence of Duane Doty, the town superintendent, who is shown here in an undated photo with his daughter. The present address of this building is 645 East 111th Street.

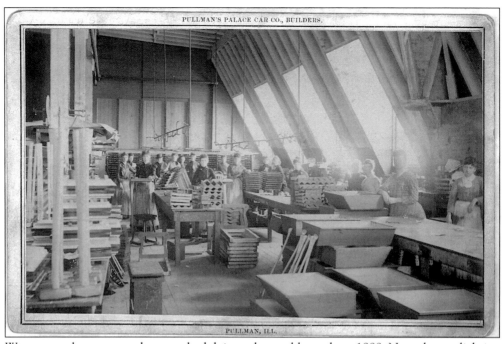

Women employees were photographed doing subassembly work, *c.* 1888. Note the gas lighting piping above the workbenches.

Edward Casey was one of the operators of the transfer table donkey engine. This photo was taken *c.* 1890.

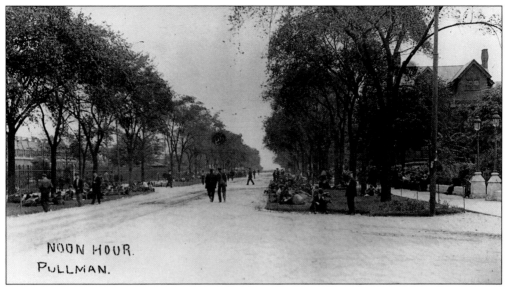

This Koopman photo shows noontime at Pullman, *c.* 1900. Every day at noontime, footsteps echoed throughout the town as employees walked home for lunch on the wooden sidewalks. Other employees are eating their lunch and lounging in the grass alongside 111th Street (Florence Boulevard). (Courtesy of Pullman Research Group.)

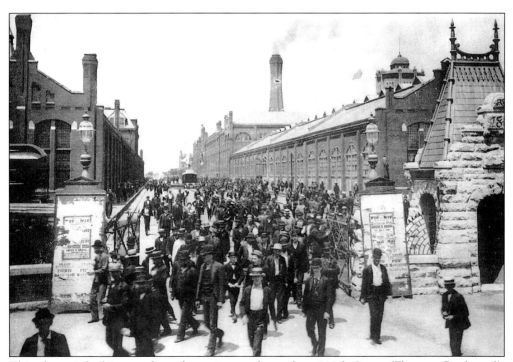

This photo is looking north at the main gate located on 111th Street (Florence Boulevard). The workers are leaving at lunch time or at the end of the day shift. Note the posters at the gate advertising an upcoming company picnic.

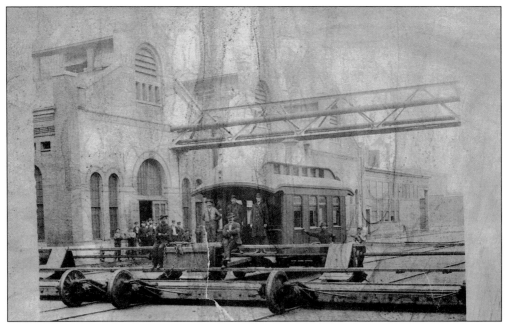

To transfer sleeping cars and coaches from one work station to another along the erection shop, a transfer table was used. This was moved by a small donkey engine constructed from an old passenger coach. The car would be lined up with the track at its new location and it would be pulled in for the next construction phase. This photo, now in poor condition, was taken about 1890.

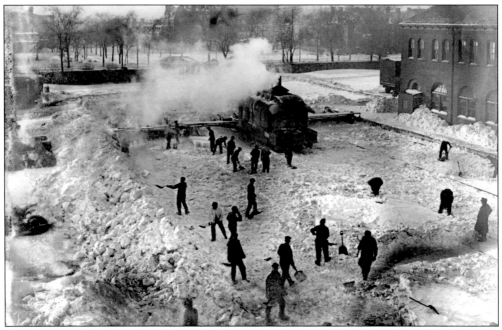

This is a view of the transfer table in 1890 looking south toward Langley Avenue. Employees are shoveling snow so that the transfer of cars can continue after a major storm stopped production in the adjacent building.

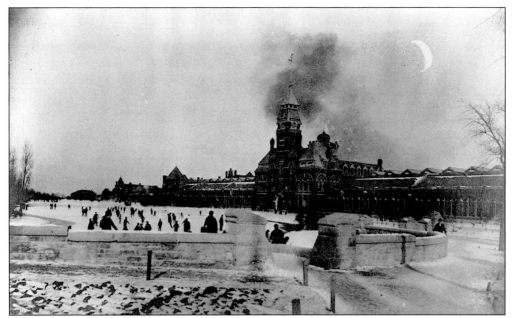

This photograph of ice skaters on Lake Vista in 1892 is a rare one. Normally the winters in the Chicago area would not freeze over this cooling pond because of the circulating warm water used to condense the exhaust of the Corliss engine. The winter of 1892–1893 was unusually cold. Photographer Koopman added the moon to the sky in this photo.

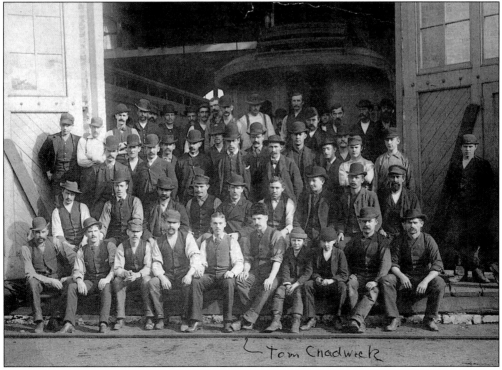

Tom Chadwick is seen here as part of a group of employees in 1893.

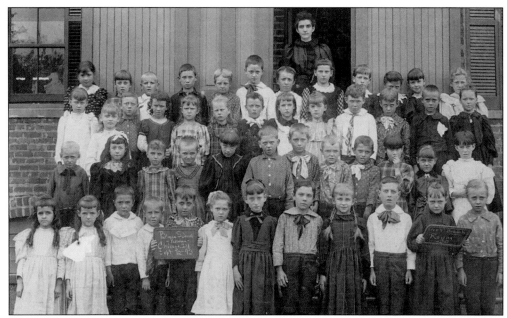

This 1893 photo was taken at the branch Pullman School, located on the northeast corner of Corliss Avenue and 105th Street. The teacher is Miss Florence Fickell.

This group photo was taken at the George M. Pullman Grade School in September 1895. Miss Florence Fickell is the teacher for room number ten.

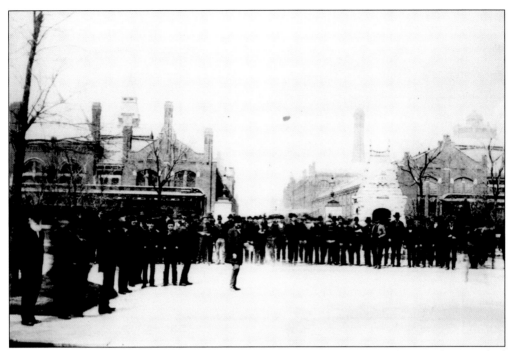

A group of employees at the main gate on 111th Street (Florence Boulevard) were photographed during the strike by the American Railway Union in 1894 against the Pullman Palace Car Company.

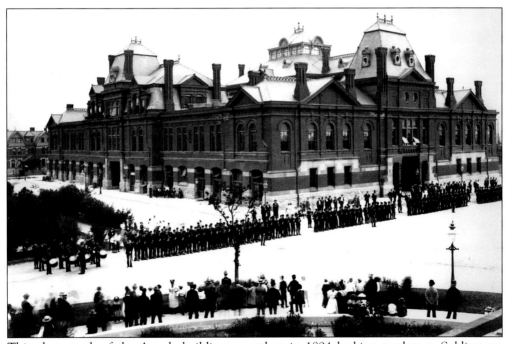

This photograph of the Arcade building was taken in 1894 looking southwest. Soldiers are grouped around the building as part of the standoff between the striking employees and the Pullman Company.

On the right in this photo is Miss Mayme Moran, born *c.* 1884. She worked in the Pullman laundry on 111th Street and later married John J. Stanley, also a Pullman employee.

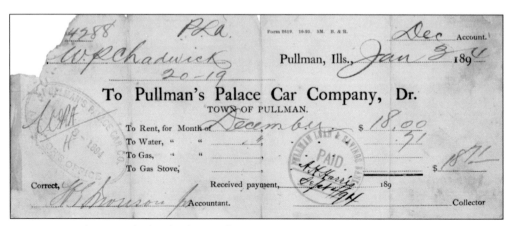

A rent receipt for W.P. Chadwick of 537 Pullman Avenue is dated January 3, 1894. Rent payments were paid to the Pullman Bank. Today this house address is 10719 Cottage Grove Avenue.

This is an 1896 lease for 131 Watt Avenue. After the houses were renumbered in 1909 and the street names changed, this house became 11143 St. Lawrence Avenue. At the time of construction George Pullman named the north-south streets after some of his favorite inventors and developers, e.g. Watt, Morse, Corliss, Stevenson, etc. The present 111th Street was named Florence Boulevard after his first-born daughter.

An unknown couple poses at the rear of their house on Champlain (Stevenson) Avenue in 1896. This rare photograph is the only known view of an early Pullman backyard.

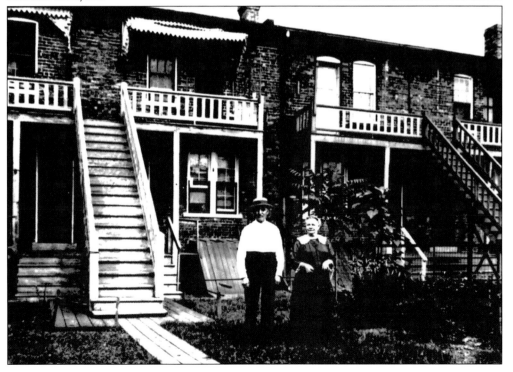

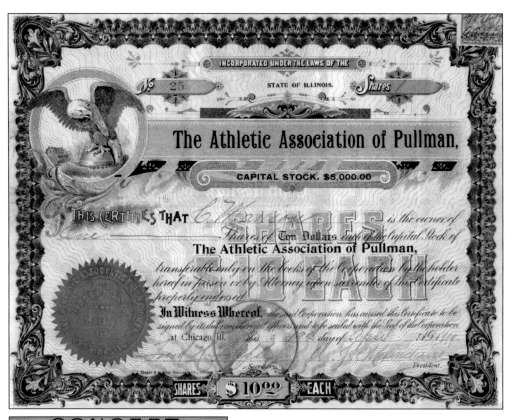

Pullman employees could invest in the capital stock of "The Athletic Association of Pullman" to support the various athletic events and teams in the community. This single share of stock was issued to C. Manson in 1899.

CONCERT
BY
First Regiment (Pullman) Band
IN
PULLMAN ATHLETIC GROUNDS
(North of Palmes Park, 110th)
Monday Evening, Aug. 17, 1903

J. F. HOSTRAWSER, Conductor.

...Program...

1. March—"Blaze Away" - - HOLTZMAN
2. Overture—"Orpheus" - - OFFENBACH
3. (a) Turkish Patrol - - MICHAELIS
 (b) Polish Dance - - SCHARWENKI
4. Solo for Cornet—"Weldonian" - SIMONS
 MR. C. H. WOLF.
5. Selection "Florodora" - - - STUART
6. Selection of Popular Melodies - CHATTAWAY
7. Vocal Solo,—"Good Night, Beloved, Good Night," - - OLIVER
 Mr. E. L. Kippen
8. Miserere from "Il Trovatore" - VERDI
9. Euphonium Solo—"Therese" - WALDRON
 Mr. O. J. May
10. Humoresque—"We Won't Go Home 'til Morning" - - DALBEY
 (As it might have been written.)

SYNOPSIS—(a) Introduction and theme ; (b) as a Spanish Waltz ; (c) as a Gavotte ; (d) as a Polka ; (e) as a Religioso ; (f) as a Galop ; (g) as a Dirge ; (h) as it is often heard, about four o'clock in the morning.

Shown here is a notice for a band concert on August 17, 1903, to be held on the Pullman Athletic Grounds north of Palmer Park and to be directed by J.F. Hostrawser.

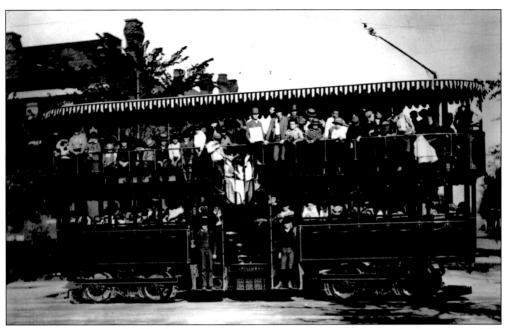

This photograph of a double-deck streetcar, *c.* 1900, was taken at the southwest corner of the erecting shop.

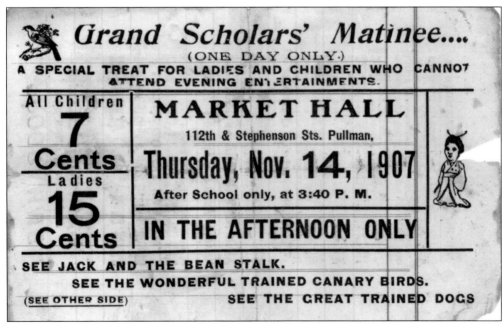

All of the homes in the community must have received this flyer for "The Grand Scholars Matinee . . ." to be held on November 14, 1907, on the second floor of the Market Hall.

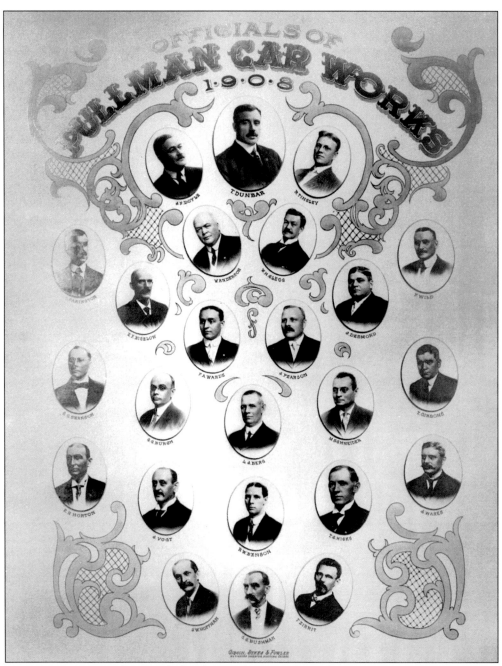

A supervisor's group photograph for the 111th Street shops that was taken in 1908 is shown here. Pictured from left to right are the following: (top row) J.F. Doyle, T. Dunbar, and R. Tinsley; (second row) W. Anderson and W.H. Clegg; (third row) S. Carington, E.F. Bieglow, F.A. Warde, J. Pearson, J. Desmond, and F. Wild; (fourth row) G.G. Swanson, C.G. Burgh, L.J. Berg, M. Schneider, and T. Gibbons; (fifth row) E.K. Horton, J. Vogt, R.W. Benson, T.G. Hicks, and J. Wares; (sixth row) J.W. Hoffman, G.S. Bushman, and T. Zirrit.

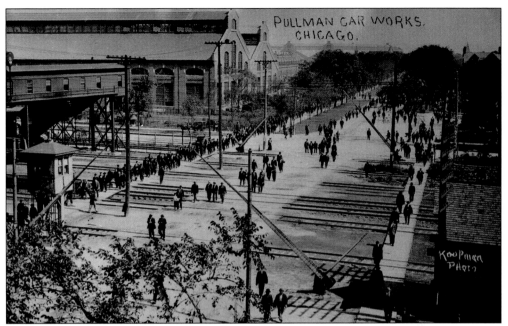

The end of the day shift is evidenced by the employees walking home west across the Illinois Central Railroad tracks at the 111th Street (Florence Boulevard) crossing. (Photograph by Koopman.)

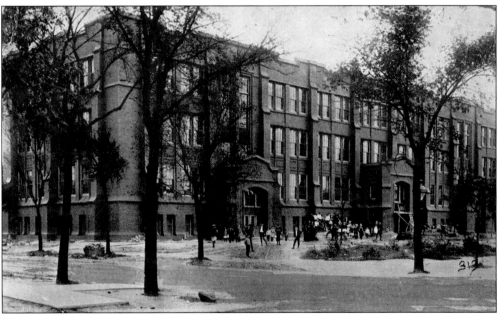

In December of 1909, Hugo Haub sent this postcard to his sister Anna in Michigan. He wrote that he was very pleased to be in such a fine school. The George M. Pullman School, designed by famous Chicago architect Dwight Perkins, replaced the original Pullman school building a block away. The new building, still in use today, is located at the corner of Forrestville Avenue and 113th Street.

This Pullman pass was issued to H.E. Reynolds, an employee of the Rock Island Railroad. Mr. Reynolds was an air brake instructor temporarily at the Pullman plant. It is likely that he was acting as an inspector for an order of cars being built at the Pullman plant for his employer.

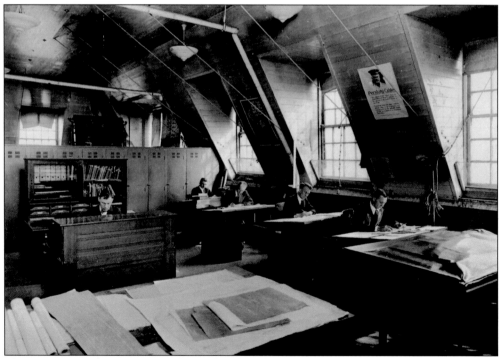

The engineering department was located in the administration building. This photo was taken in April of 1919. (Courtesy of Chicago Historical Society.)

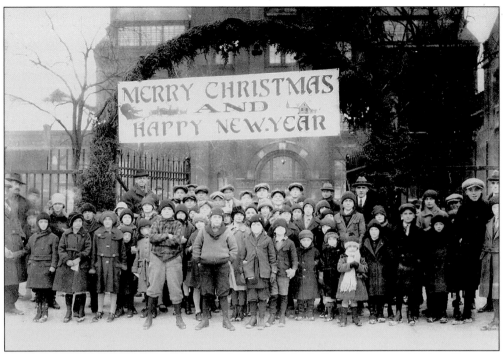

This group of schoolchildren and their teachers toured the Pullman factory c. 1915 at Christmas time. The administration building is in the background.

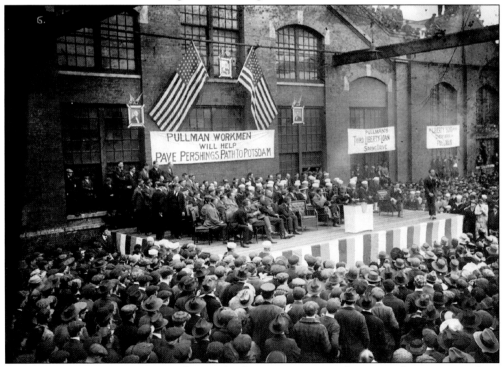

During the spring of 1918, Douglas Fairbanks Sr. is urging Pullman employees to purchase war bonds.

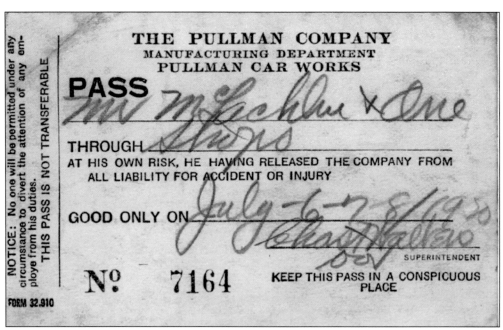

This visitor's pass for the Pullman shops was dated 1920.

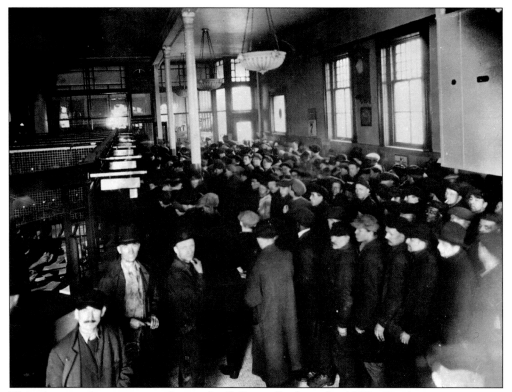

This photograph captures payday at the Pullman Bank in the 1920s. Employees are waiting to cash their paychecks. Contrary to popular rumor, Pullman employees were never paid in company script.

It is hard to believe that delivery of a baby and ten days in the hospital could cost only $50.50. The Pullman Emergency Hospital was not connected to the Pullman Company.

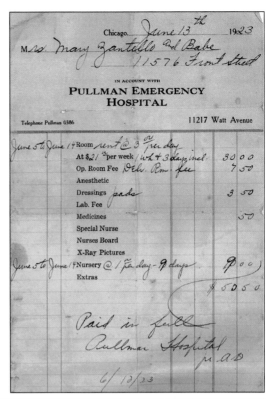

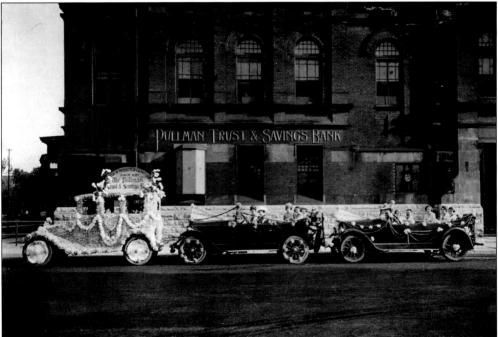

These automobiles are lined up and ready for a parade in 1925 in front of the Pullman Bank at the Arcade building. Shortly after 1925 the bank was moved to a building designed by architect Howard Van Doren Shaw. The new location was two blocks west on 111th Street.

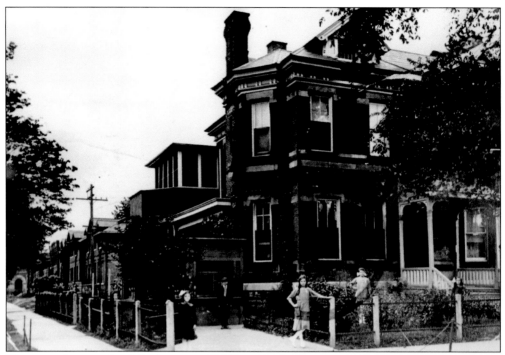

This is a photograph of the house at 623 East 111th Street in 1922. This was originally the home and office of Dr. John McLean. McLean bought the house in 1907, remaining there until he retired in 1922. The Frigo family lived there from 1922 until the 1960s. Longtime Pullman resident Liz Frigo Olsen is the third child from the left.

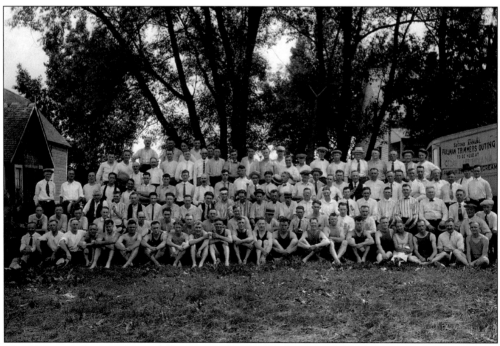

The Trimmers Second Annual Outing was held at Cedar Lake, Indiana, in 1926.

This advertising photograph was taken *c.* 1927 in the Chicago shop area with a "passenger" leaving a heavyweight sleeper.

The Broadhead meat market was located in Market Hall in the 1920s.

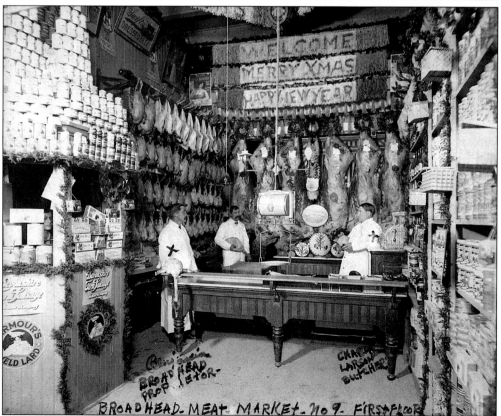

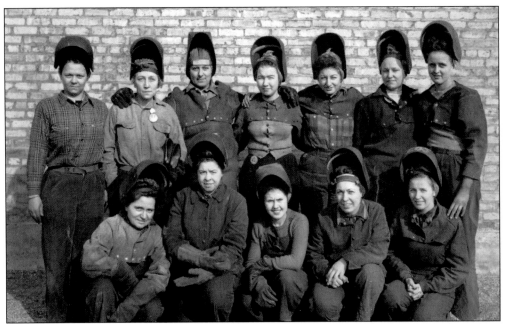

This photo shows a group of female welders at the Building No. 100 plant located north of 111th Street. The building was used during World War II to fabricate wing sections for C47 and C54 transport planes. The welders shown made subassemblies for Navy patrol craft being assembled at the Marine Division of Pullman Standard on Lake Calumet and 130th Street. This building is now owned and used by the Ryerson Steel Company.

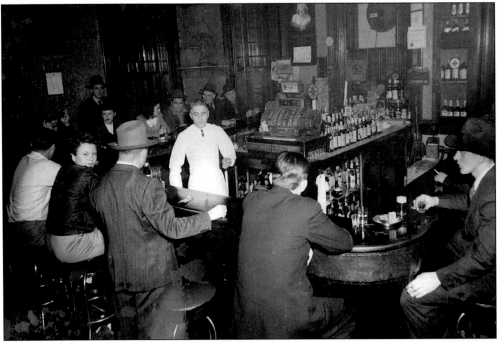

The bar at the Hotel Florence seemed to be always busy in the 1940s. In the 1970s, after purchase by the Historic Pullman Foundation, the bar was moved to the opposite wall.

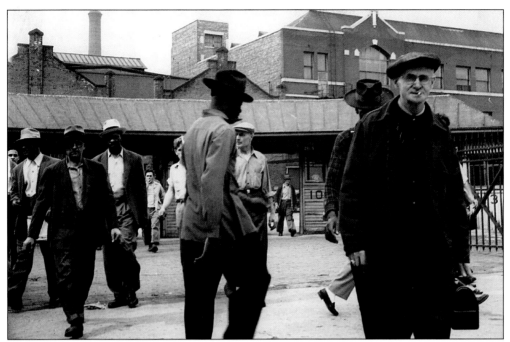

This photograph was taken during the change of shift at the main shop gate on 111th Street and Champlain Avenue during World War II.

Mary (Mayme) Stanley, born about 1886, was the oldest resident of the community at the time of her death. Mrs. Stanley, who lived all of her life in Pullman, died in the early 1990s at 104 years of age. (*Calumet Index* photo.)

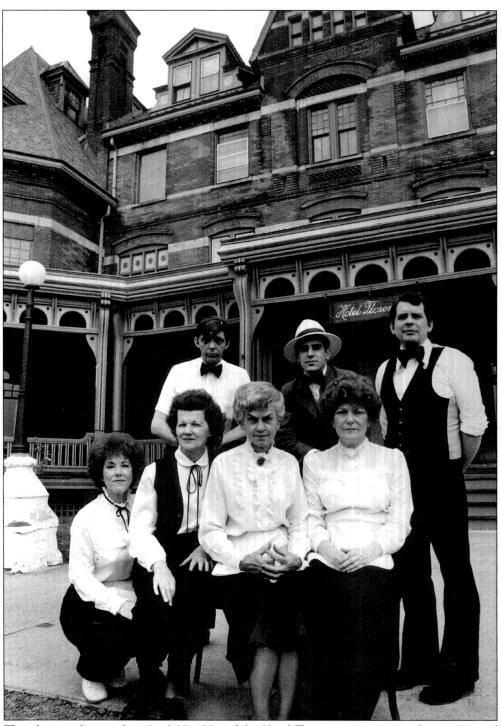

This photograph was taken April 28, 1981, of the Hotel Florence restaurant employees. Pictured here are, from left to right, the following: (front row) Billee Chiagouris, Penny Pinianski, Peggy Avignone, and Dorothy Watson; (back row) Glenn Anderson, James Stulga, and Richard Jackson.

Five

HOTEL FLORENCE

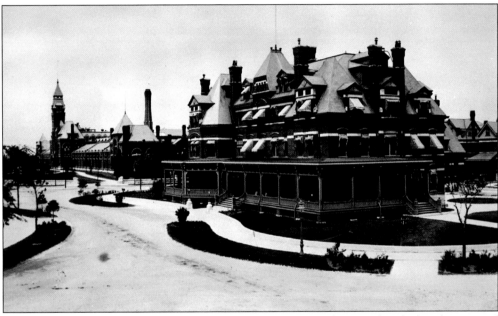

The Hotel Florence is viewed from the southwest in this 1884 photograph. The hotel contained a restaurant, barbershop, bar, and pool room. This 50-room hotel was opened in November of 1881 and was named after Pullman's first-born daughter, Florence. It cost $100,000 to build, and the Eastlake furniture, manufactured by the Tobey Company, was selected by Mrs. Pullman. The furniture added $31,000 to the cost. The building sat on an acre of ground and was steam heated. Guest rooms rented from $2 to $3 per night and weekly rates were available. First-class rooms were located on the second floor and second-class rooms were on the third and fourth floors. There were two bathrooms on each floor that the guests shared. The modern kitchen had gas stoves and ovens. The hotel had telephonic and telegraphic conveniences such as were found in all first-class houses at that time. Celebrities from all over the world have been guests here. It is a landmark proudly recalling the glory of Pullman in its early days.

The Pullman Company owned the Hotel Florence from 1881 until 1898. Other owners have been as follows:

Mrs. and Mrs. Hermann Goetz	1898–1910
Mr. and Mrs. William Fischer Sr.	1910–1947
Mr. and Mrs. William Fischer Jr.	1947–1971
Thomas Hutmann	1971–1975
Historic Pullman Foundation	1975–1991
Illinois Historic Preservation Agency	Present

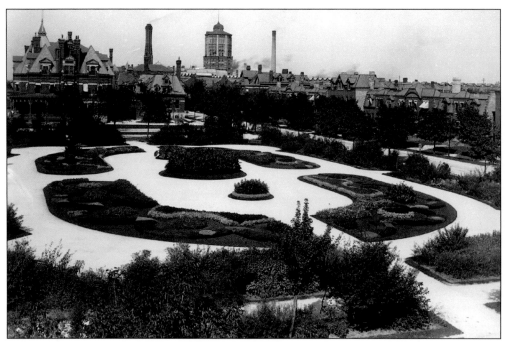

This 1883 photo is of Arcade Park looking north from 112th Street to the hotel with the water tower in the background. The residential buildings around the park and the public buildings were heated by steam supplied by underground piping from the factory. This was one of the first examples of district steam heating in the United States.

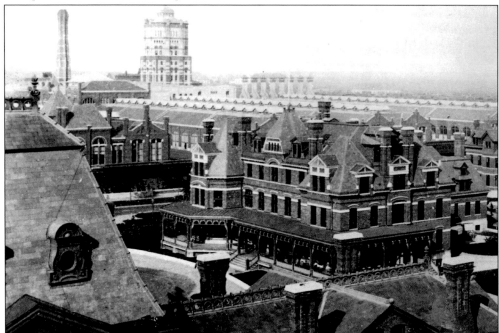

This is an 1890 Koopman photograph showing the Florence Hotel and the shops. In addition to the guest rooms, the hotel contained some rooms for the employees in the building extension to the rear.

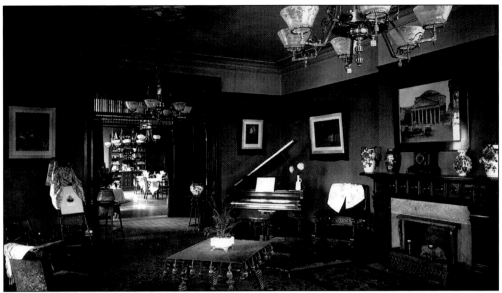

The main parlor of the Hotel Florence is pictured here in October 1897.

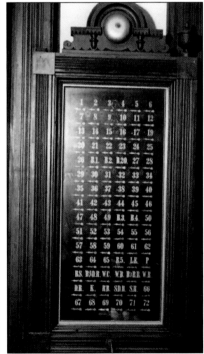

Left: This is the main parlor of the hotel. Note that the ceiling has been covered with decorative tin sheet as shown in this undated photo.

Right: This is a contemporary photo of the hotel fire annunciator panel, which was located in the lobby office and was manufactured by Western Electric Company. Each guest room had a heat sensor which would activate one of the indicators on the panel and sound an alarm bell. A push button in each room was installed on the system so that guests could call a maid or waiter for service.

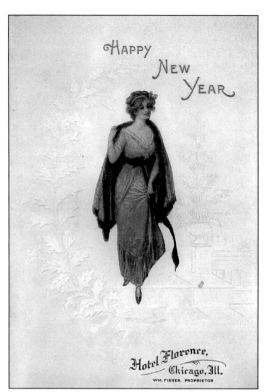

This is the Hotel Florence New Year dinner menu cover for 1914.

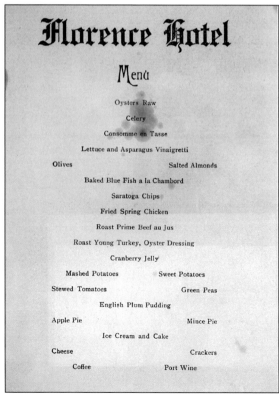

The menu as contained within the front and rear covers for 1914 is shown here.

One of the permanent hotel guests is sitting in the main parlor. The painting above the fireplace is that of William Fischer Sr., owner of the hotel from 1910 until 1947. Mr. Fischer purchased the Hotel Florence from Hermann Goetz, who had purchased it from the Pullman Company in 1898.

These room rules cards were framed and hung in each room of the hotel.

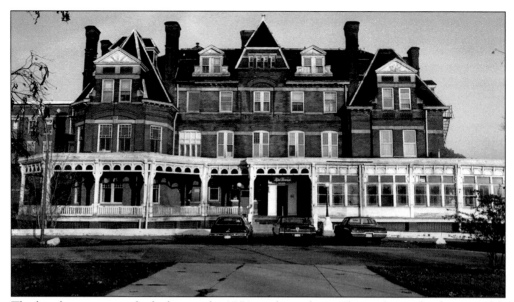

The hotel exterior as it looked up to the 1970s is shown here. The enclosure for the verandah was added after the Prohibition era. Under ownership of the Historic Pullman Foundation, the enclosure was removed so as to return the verandah to the original design.

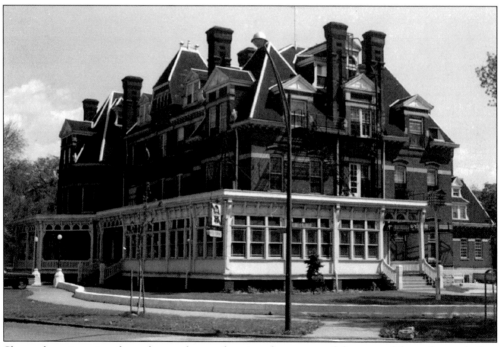

Shown here is a view from the southwest showing the extent of the verandah enclosure before it was removed.

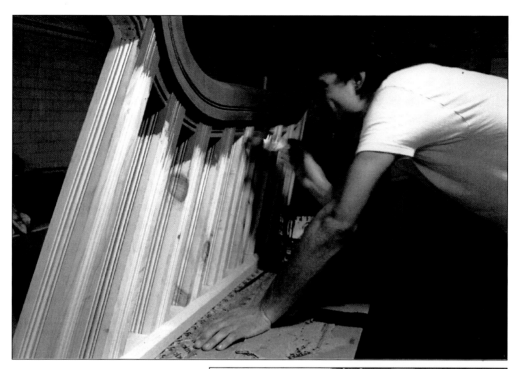

By the 1970s the step railing for the main entrance had deteriorated to the point that replacement was necessary. This volunteer is painting a new section of railing before installation of the steps.

An annex with 50 rooms was added c. 1914 to the Hotel Florence when the change-over from wood to steel car construction made it necessary to hire additional workers at the Pullman Company. The corner of the annex on 111th Street (Florence Boulevard) and St. Lawrence (Watt) Avenue contained a cafeteria which did business up to 1977. After the Historic Pullman Foundation bought the hotel, the sign was removed from the building.

A new roof of imitation slate was installed on the hotel in the 1970s.

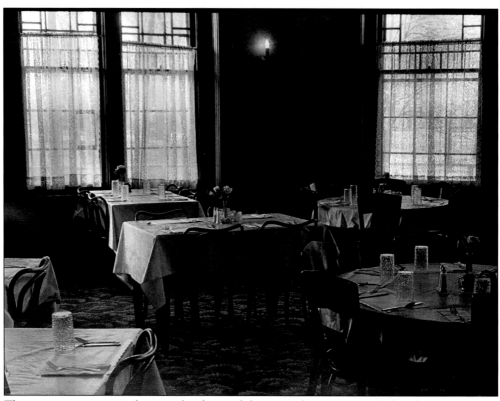

This is a contemporary photograph of one of the main dining rooms. Today the restaurant is active with lunch being served on business days and brunch on Sundays. The space is also used for private parties and banquets. The second floor of the Hotel Florence contains a museum.

Shown here are typical examples of the brass door hardware found throughout the hotel. Several different patterns or designs are original to the construction of the hotel in 1881.

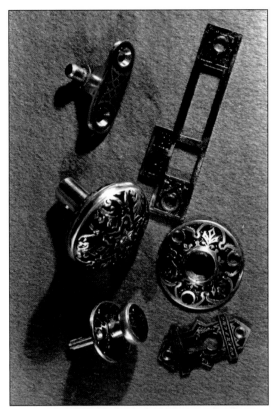

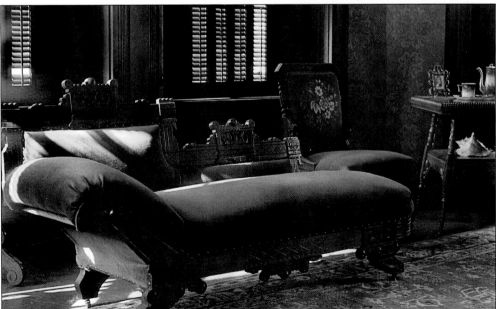

Room number one on the second floor is shown in this photograph. This room was permanently reserved for George Pullman, who frequently stayed overnight during visits to Pullman. The room was restored by volunteers during the 1970s. Furniture in the room is not original to the hotel and was donated by various members of the community.

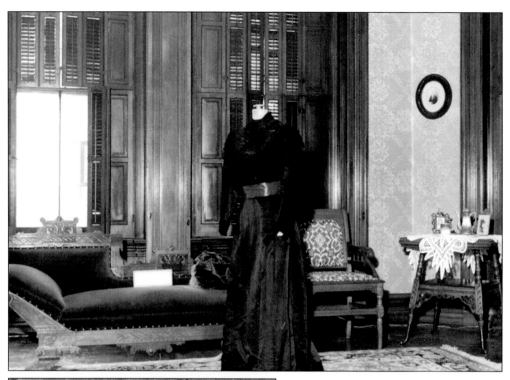

This is another view of room number one showing one of a collection of period dresses collected by Pullman resident Lorraine Brochu on loan for display.

This is a corner of room number 14 on the second floor of the Hotel Florence. This room is used as the town of Pullman exhibit room and contains photographs and maps.

Restored guest room number eight is shown here. The restoration work was done by volunteers from the community. The furniture, Eastlake in style, is original to the Hotel Florence and was selected by Mrs. Pullman.

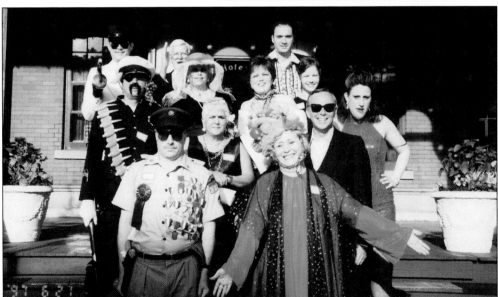

The Ho-Flo Players gathered on the steps of the Hotel Florence for a photograph before their June 1997 performance of *Chiquita*. From left to right, the players are as follows: (first row) Lou Bertoletti and Nancy Gahan; (second row) Toni Molski and Tom McMahon; (third row) Ben Kocolowski, Colleen Lira, Deborah Bertoletti, Sheila Bertoletti, and Lisa Maurizi; (last row) Father Bill Stenzel, George Ryan, and Al Quiroz Jr.

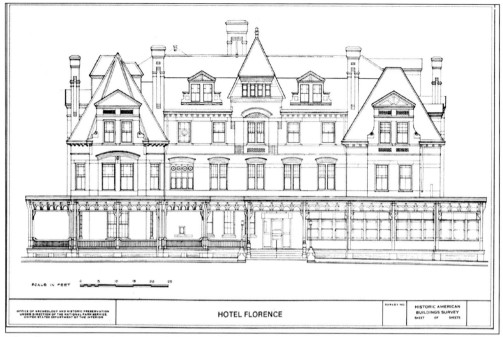

HOTEL FLORENCE

This drawing is an elevation of the Hotel Florence. (Courtesy of Historic American Buildings Survey, National Park Service, and United States Department of the Interior.)

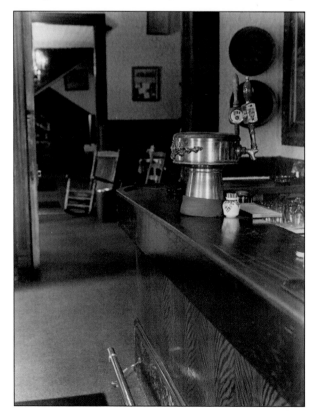

Shortly after the Historic Pullman Foundation purchased the hotel, the bar was moved to the opposite side of the barroom, providing ease of entrance and exit.

Six

GREENSTONE CHURCH

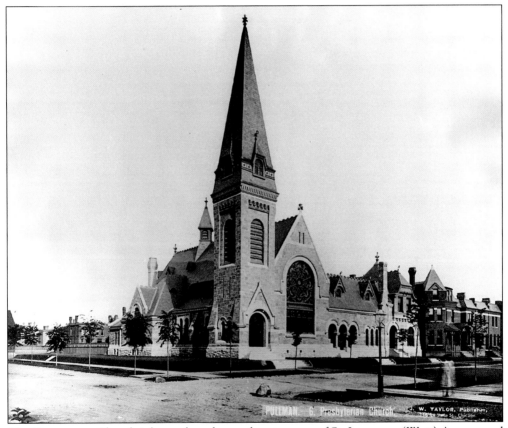

The Greenstone Church is located on the southeast corner of St. Lawrence (Watt) Avenue and 112th Street. Although the intention in the spring of 1881 was "for all to unite in a union body and get a broad-minded evangelical clergyman," it was quickly realized that each denomination wanted to worship in their own religion and their own language. The church building sat empty due to the high monthly rent while small religious societies met in rooms rented at the Market Hall, the Arcade, or the Casino buildings. The Presbyterians were the first tenants of the church, having leased the building by 1887. However, the church building was sold in 1907 to the Methodists. Today the Pullman United Methodist Church has a membership of approximately 80 families.

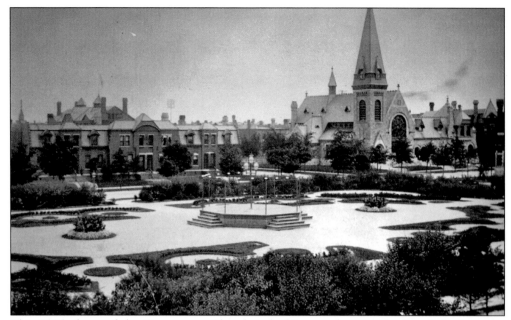

This 1885 photo of the Greenstone Church is looking southeast with Arcade Park in the foreground. The residence at the left was demolished to make way for a new house in 1892. The entrance to the alley at the rear of the church originally had a decorative arch. There were several of these arches in the community and they all had to be removed with the increased size of the garbage trucks.

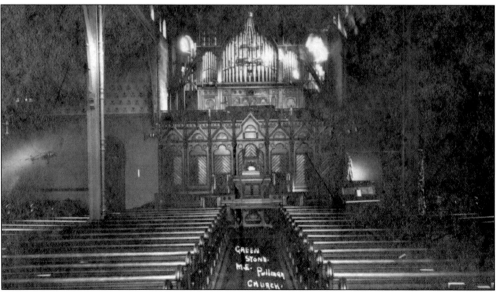

This interior photo of the Greenstone Church was taken by photographer Koopman. The original organ, still in operation, was manufactured in Springfield, Massachusetts, by Steere and Turner in 1882 as their Opus Number 170. Originally the air supply to the organ was supplied by a blower powered by a water motor. Later this drive was replaced by an electric motor. Once a year concerts are given on the organ, which has been listed by the Organ Historical Society. Funds generated by these concerts are used to maintain the historic organ.

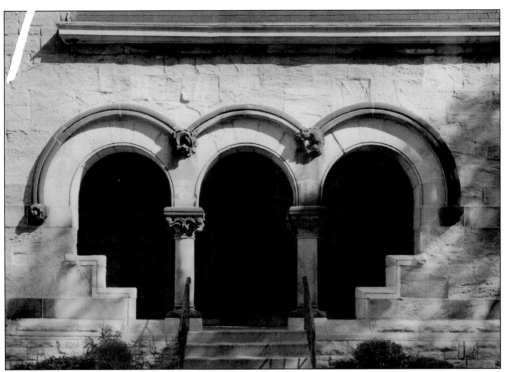

This arched doorway of the church opens to the right aisle. The façade was built with Pennsylvania serpentine stone, thus the name "Greenstone."

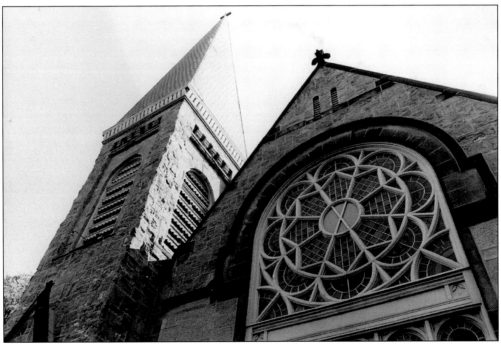

The Rose Window of the Greenstone Church is shown after being rebuilt in 1985. Most of the stained glass is original.

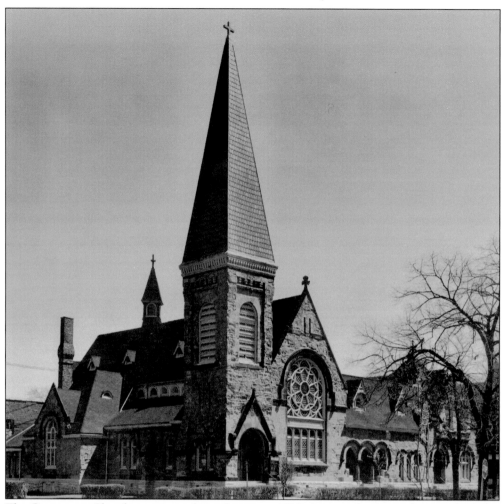

The Greenstone Church exterior is shown here in a 1991 photograph. As can be seen from this photo, the building has received tender loving care by many generations of Pullmanites. In the early days, the building rental of $300 per month was too expensive for many of the small religious societies in the community. This is made evident from a list of church groups that rented space in the close-by Arcade building and advertised their services in the *Pullman Journal* of 1893:

"*Directory Good Templars, Hall Rooms 53 and 55 Arcade Building.* Episcopal Church Society: Services held every Tuesday night: Sabbath school every Sunday, 9:30 a.m. We confidently expect that the Episcopal people will have regular Sunday services in the near future.

Colored Baptist Church Society. Sunday school every Sunday at 2:00 p.m. Preaching services at 7:30 p.m. Rooms 53 and 55.

Directory of Swedish M.E. Church, Rooms 60 and 62 Arcade. Services in the Swedish language: Sunday 9 o'clock, Sunday-school. Chas. Lindquist, superintendent; preaching, 10:30 a.m. and 7:30 p.m.

Directory of the Baptist Church. All services held in Room 61, Arcade, Pullman. Sunday-Preaching, 10:30 a.m. and 7:45 p.m. Fred Berry, Pastor, Residence, 371 Morse Ave., Pullman."

Seven

MARKET HALL, CASINO, AND STABLES

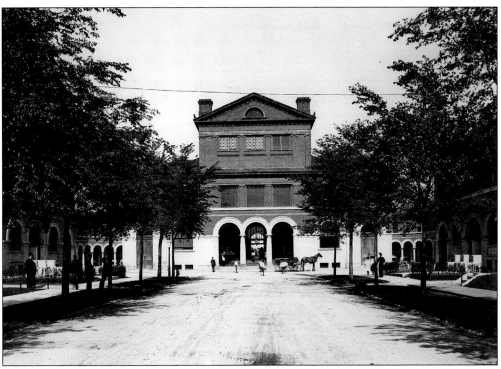

The second Market Hall building (photo taken c. 1895) was constructed in 1892–1893 on the site of the first Market Hall. The second floor was an assembly hall with stage facilities. The third floor contained lodge rooms. The top floor of the building was removed in the 1930s. Parents of Eliot Ness, the well-known treasury officer who led the Chicago "Untouchables," had a bakery in the building at one time. The oven of the Ness bakery, located in the basement of the building, appears today to be still in relatively good condition.

The Market Hall was built with dimensions of 112 by 106 feet and contained 12 stalls (shops) on the first floor. The first floor is supported by brick columns with rather pleasing arches. The support columns for the upper floors that extend from the first floor are of cast iron. Lighting for the interior was supplied by circular skylights on the north and south sides. The first floor also had windows for lighting and ventilation. Gas lighting was used throughout the building until it was replaced by electricity.

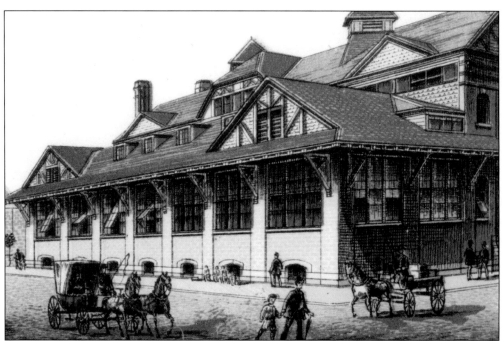

This engraving of the original Market Hall was produced from an S.S. Beman drawing. Usually, a small group of these lithographs were made up as souvenir booklets.

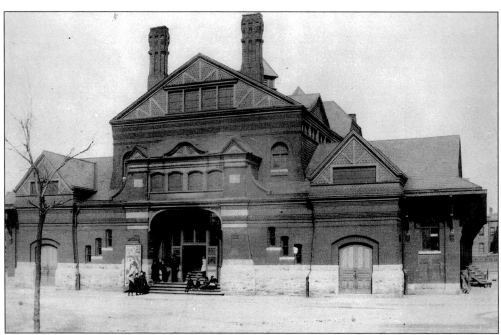

The first Market Hall was located at the intersection of 112th Street and Champlain (Stevenson) Avenue. The building had 16 stalls (stores) and a lunch counter. Produce, meats, etc. could be purchased in the building. The second floor could be rented for social or business meetings. The third floor contained additional meeting rooms. This building burned to the ground on April 7, 1892.

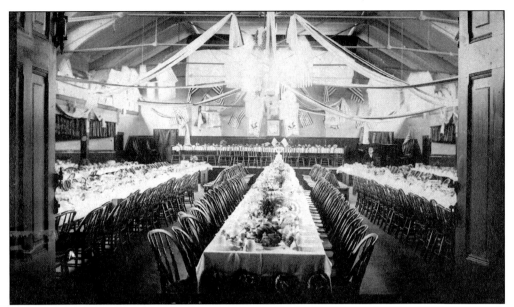

The second floor of the rebuilt Market Hall had space to seat 600 people. This 1900 photograph by Koopman shows a banquet set up for the Patriotic Order of Sons of America organization.

GOOD NABORS HELP ONE ANOTHER

A GOOD DRUG STORE

is needed in every community. It serves in a thousand ways.
It is unsafe without one.

CALDWELL'S DRUG STORE

MARKET HALL, PULLMAN

is a Good Drug Store and he and "Ma" are Good Neighbors.
The more you trade with them the more they can do for you.

PHONE PULLMAN 0018 THEY WILL SEND IT

"YOU GET THE BEST AT THE DRUG STORE"
IT PAYS TO TRADE WHERE YOU TRADE IN SAFETY.

This is an advertising blotter for Caldwell's Drug Store in the Market Hall.

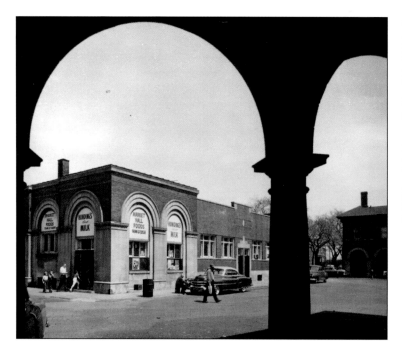

The Market Hall building is shown here as it appeared in the 1970s. The upper half of the building was removed in the 1930s. Another fire in 1974 destroyed the roof and interior. Today there are plans to restore the building for use as a community center.

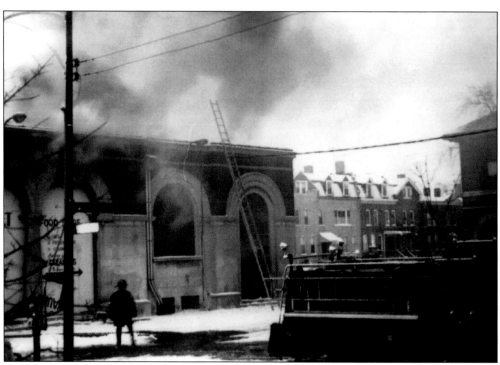

This photo shows the activity during the 1974 fire at Market Hall.

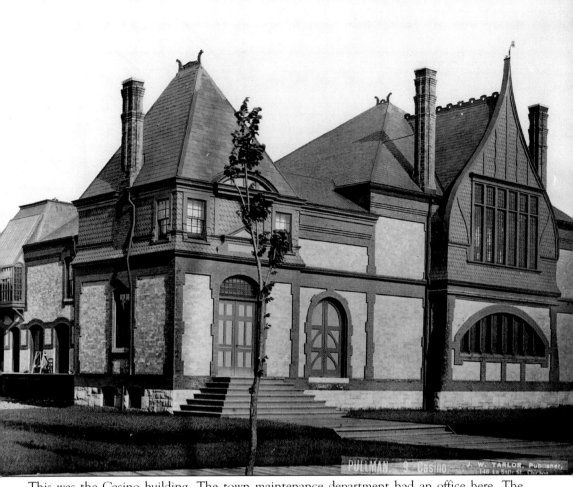

This was the Casino building. The town maintenance department had an office here. The second floor was used for lodge meetings. All Saints Episcopal Church met here in 1883 and then met in the Arcade building for 19 years. The Pullman Methodist Episcopal Church met here in 1881 until they purchased the Greenstone Church building (now Pullman United Methodist Church). The Casino building also housed the town undertaker and photographer. After the building was demolished, an industrial building (not connected with the Pullman Company) was built on this site. In 1998 this building was pulled down, revealing part of the original Casino building foundation. Note that the architectural detailing of the chimneys is totally different from those on the other Pullman community buildings.

The office of architect Solon S. Beman produced this drawing of the livery stables. This building is still located on 112th Street and Cottage Grove (Pullman) Avenue.

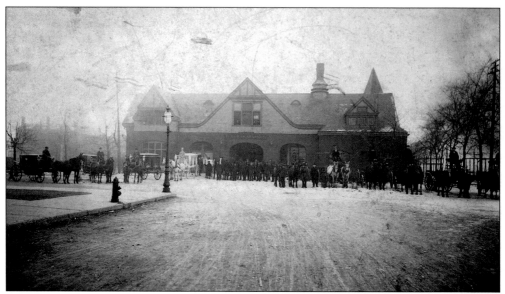

This is a view of the stables looking south. This building contained the equipment for the Pullman Fire Department and the Central Telephone station. As horses could not be kept on the tenants' premises, it was possible to rent a horse and carriage from this location. Visitors to the community were required to stable their horse here. Note the horse-drawn hearse in the background of this photograph.

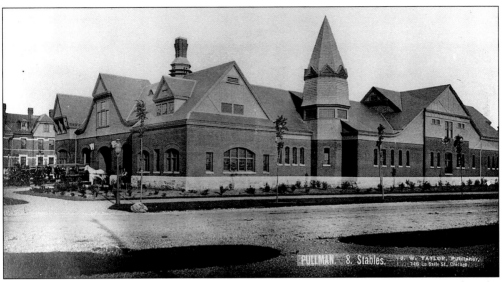

This shows a view of the stables in 1887, with the ornamental tower that was removed in the 1890s. The town undertaker kept his horse and the hearse at this location.

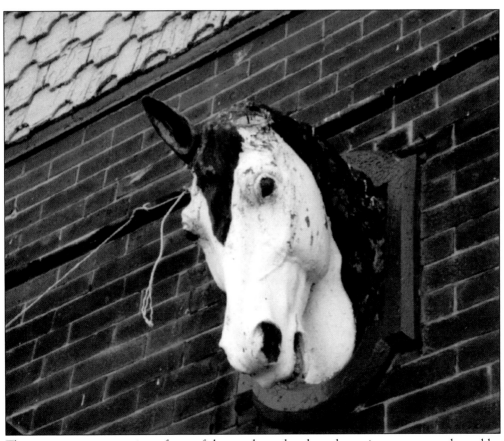

This is a contemporary view of one of the two horse heads at the main entrance to the stables building. While the heads appear tired and worn, they still look north to the Hotel Florence.

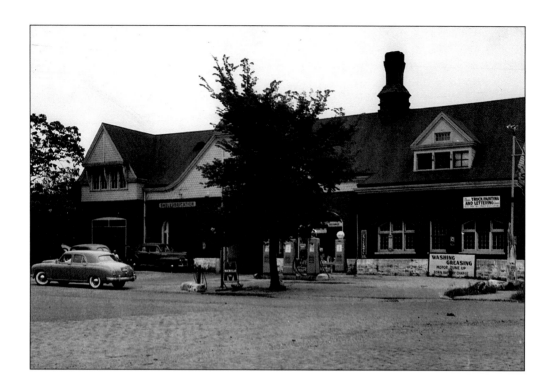

This 1940s photo of the livery stable shows that it had become a gasoline service station and automobile repair shop. Today the first floor of the building is still an automobile repair shop, as shown in the photo below. A dance studio is located on the second floor.

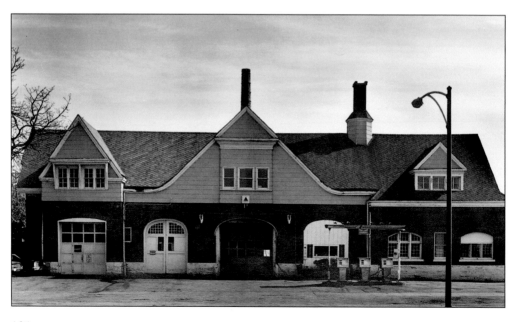

Eight

ARCADE, SCHOOL BUILDINGS, AND RAILROAD DEPOTS

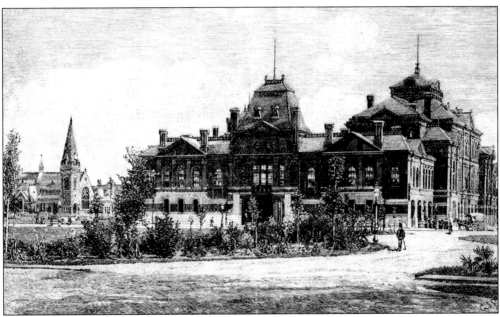

A lithograph of the Arcade building, located on Cottage Grove Avenue (Pullman Boulevard) between 111th Place and 112th Street, is shown here. This was one of the first enclosed shopping centers in the United States. The building measured 250 feet long and 166 feet wide with a height of 90 feet and covered nearly an acre of land. The first floor consisted of the Pullman Bank and the post office, as well as stores selling dry goods, groceries, boots and shoes, china and glassware, clothing, household furniture, hardware, tobacco and cigars, medicines, clocks, watches and jewelry, and a restaurant. The Pullman Company had no interest in any mercantile business located in the town; they simply rented stores to businessmen who had to compete with the immediate neighborhood, the shops in Roseland, and Chicago for trade. The second floor contained the town agent's office, the Arcade Theatre, and the Pullman Library.

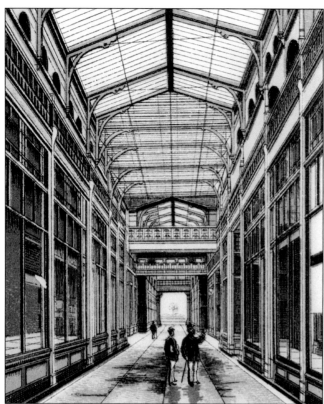

This is another lithograph showing the first floor of the Arcade building.

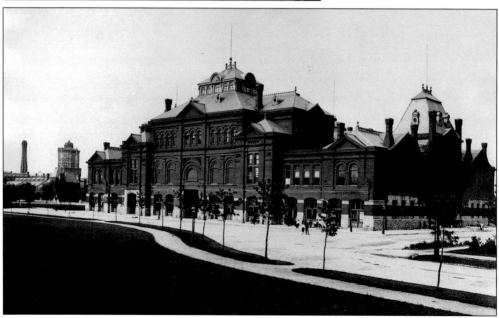

The Arcade building contained a number of shops at ground level, and the businessmen priced their goods competitively. The Arcade Theatre was located on the second floor along with various offices including that of the town agent. The town agent was responsible for the maintenance and rental of the residential buildings.

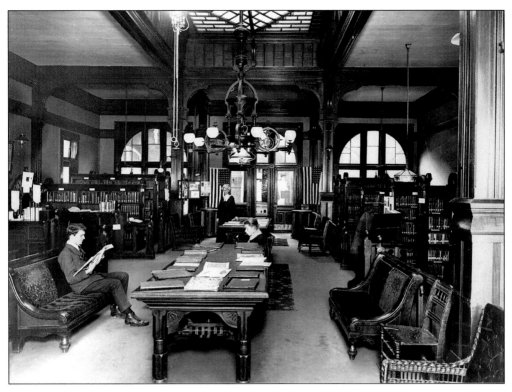

The Pullman Library was located on the second floor of the Arcade building. The five-room library with over 5,000 volumes opened to the public April 10, 1883. Professor David Swing of Chicago made the dedicatory address in the Pullman Theatre on May 10, 1883. After the conclusion of the exercises, all present were invited to visit the library rooms (five in number), located in the southwest corner of the Arcade building. As was common at that time, a small yearly membership fee was required. (Courtesy of Chicago Historical Society.)

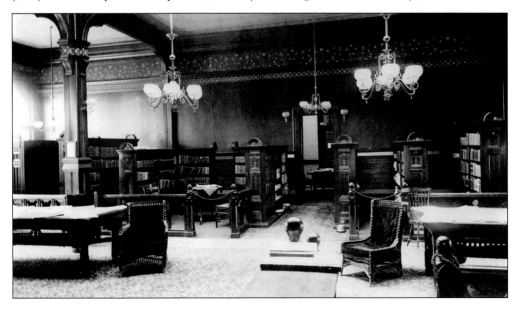

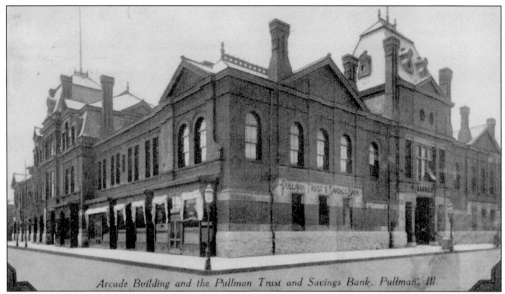

Arcade Building and the Pullman Trust and Savings Bank. Pullman, Ill.

The Pullman Trust and Savings Bank opened for business on May 7, 1883. It was located in the Arcade building, which also housed the post office, the Arcade Theatre, the Pullman Library, and many shops. George Pullman was on the board of directors of the bank at its founding in 1883.

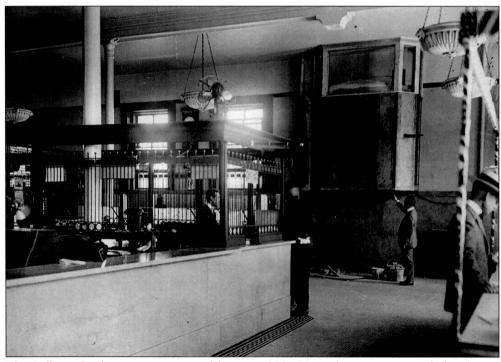

The Pullman Bank interior is pictured here c. 1920s. Note the concrete guard chamber in the right center background. A guard was on duty here during normal banking hours. This is not surprising when it is remembered that this was the era and territory of the bank robber John Dillinger.

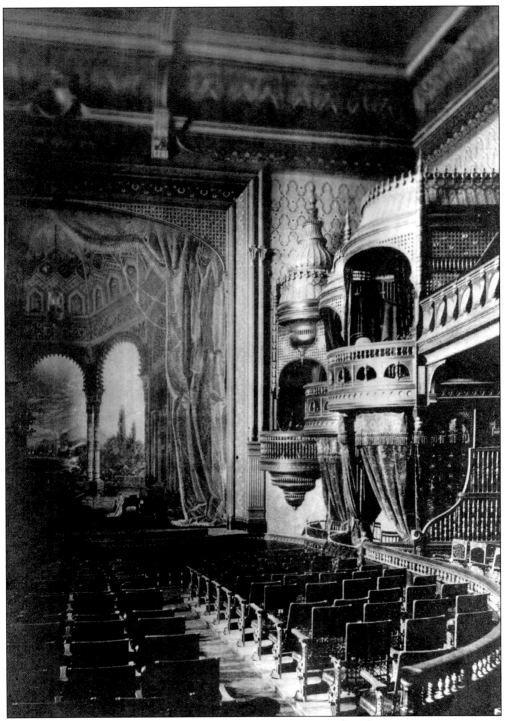

The opulent Arcade Theatre could accommodate 1,000 people. The interior appointments were executed by Hughson Hawley, who was famous for his work on the Madison Square Theater in New York City. George Pullman brought many guests to the theater on special trains from Chicago.

MUSICAL AND LITERARY
ENTERTAINMENT

Arcade Theatre, Pullman. For the Benefit
 of the
 Pullman Public Library.

Programme

TUESDAY EVENING, DEC. 29, 1891

SELECTION: (a) Ballet Music from "Astorga" Albert
 (b) Pilgrim's Song of Hope Batiste
 Pullman Military Band.
BALLAD: The Chorister Sullivan
 Master Carl Asp.
READING: (a) At the Concert Lathrop
 (b) Kentucky Belle . . . Constance Fenimore Woolson
 Mrs. FitzHenry McClure.
SONG: O Jugend, wie bist du so schön Abt
 Mrs. H. A. Hall.
 Violin obligato, Mr. H. A. Hall.

FROM THE LIBRARY TO JAPAN AND CHINA WITH MRS. F. L. FAKE.
Assisted by the
 Princess Cherry Blossom . . Miss Amory
 Princess Pearl . . Miss Lilliankrana

SONG: (a) Little Boy Blue Ethelbert Nevin
 (b) Hearts and Fancies Goring Thomas
 Mrs. Jas. Stephens Martin.
READING: The Three Wrens Phoebe Cary
 Mrs. FitzHenry McClure.
SONG: Marguerite's Three Bouquets Benza
 Mrs. H. A. Hall.
 Violin obligato, Mr. H. A. Hall.
SONG: Ye Banks and Braes o' Bonnie Doon . . . Burns
 Master Carl Asp.
GRAND SELECTION: Faust Gounod
 Pullman Military Band.

• • •

Accompanist, Mrs. H. H. Sessions.

Pictured here is a program for musical and literary entertainment at the Arcade Theatre on December 29, 1891. Note that this event, for the benefit of the library, had as an accompanist Mrs. H.H. Sessions, the wife of the plant manager.

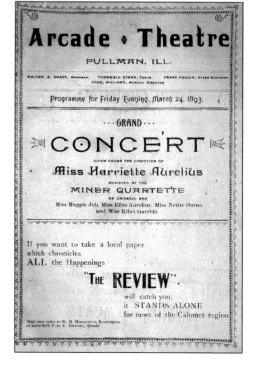

This concert program of 1893 indicates that the Arcade Theatre was one of the major cultural powerhouses of the Chicago south side in the late 1800s. This program consists of four pages which include local business advertising.

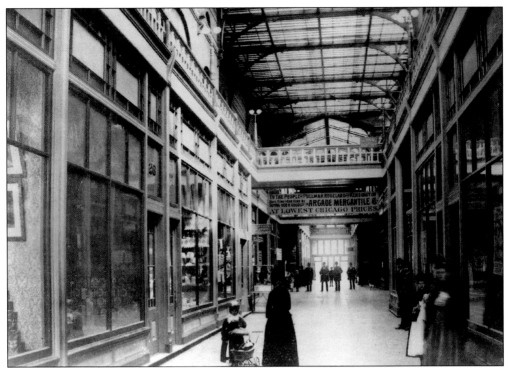

These are additional views of the Arcade building. Mrs. Pullman bought the Arcade building c. 1907–1908. In 1922 the Pullman Estate sold the building to the Pullman Company. At that time Pullman Bank began to make plans to move to a new building at 111th Street and South Park Avenue.

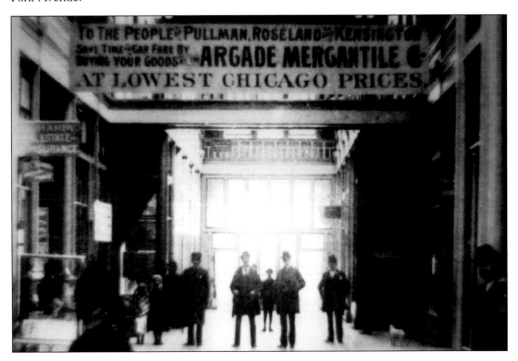

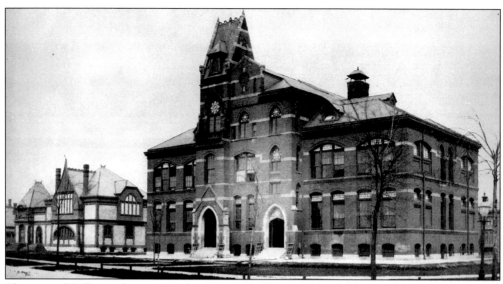

The original Pullman elementary school was called Union School. This was located at the corner of East 113th Street and Cottage Grove (Pullman) Avenue. It contained 13 classrooms and could accommodate 800 students. Daniel R. Martin was principal of the Pullman school for many years. The school was demolished in 1913, having been replaced by the George M. Pullman School one-half block east of the old site. The Casino building is located to the far left.

Register of the Attendance of Pupils in a Common School kept by *Florence Ferguson* in District No. 11 Township No. 37 Range 14, 8

No.	NAMES OF PUPILS.	Age.	Monthly Summary
1	Edward Brown	11	19
2	Willie Underdown	13	21
3	Willie Robbins	12	22
4	Bernhart Stormer	9	21
5	Samuel Nileson	9	22
6	John Cummin	10	21
7	Willie Taft	9	4
8	Bennie Shreve	9	22
9	George Penrose	8	22
10	George Brown	10	8
11	Charlie Johnson	9	21
12	Lewis Weber	12	21
13	Joe Carlin	9	21
14	Matthew Lumner	9	22
15	Charlie Rehberg	10	21
16	David Ross	11	22
17	Gus Peterson	10	22

This school register for a Pullman elementary school of January 2, 1883, lists some of the students. Miss Florence Ferguson was the teacher. At this time, the Pullman school was a township school lying in Township Number 37, District 11. Classes for these students were held in the freight depot and the Market Hall until the new building was completed in February 1883.

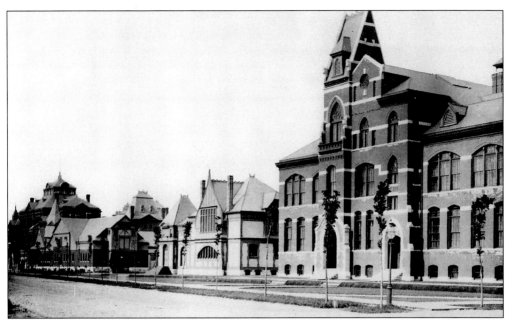

Here is a photo taken from Pullman (Cottage Grove) Avenue showing the old school building, Casino building, stables, and Arcade building.

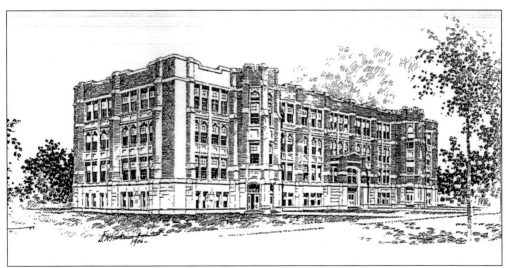

The new George M. Pullman School opened in 1909. The architect for this building was Chicago architect Dwight Perkins. It was praised as "one of the best in the State of Illinois." It was three stories tall and contained 14 rooms. "Lavatories and cloak-rooms are attached to each school-room and the interior is finished in light wood-work and with light-colored, painted walls."

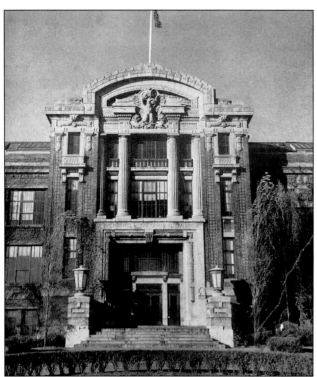

George Pullman left in his will the sum of $1,200,000 to establish a school "for the benefit of persons living or employed at Pullman." This opened in 1915 and was closed in 1949. This photo shows the main entrance to the Pullman School of Manual Training, or as it was called locally, "Pullman Tech." The school became a first-rate trade school. An active alumni association still meets annually.

This aerial photo shows the school site on a 40-acre campus at 111th Street and South Park Avenue (now Martin Luther King Drive). The building had over 73,000 square feet of usable area. These buildings are still considered masterpieces of construction.

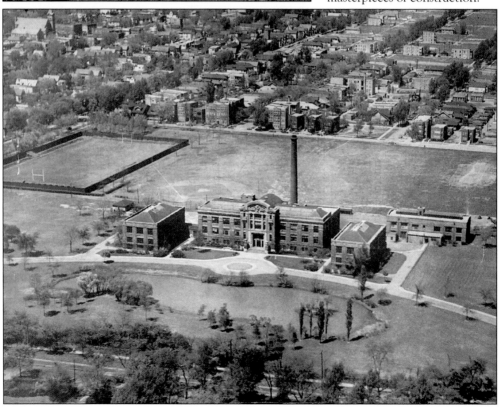

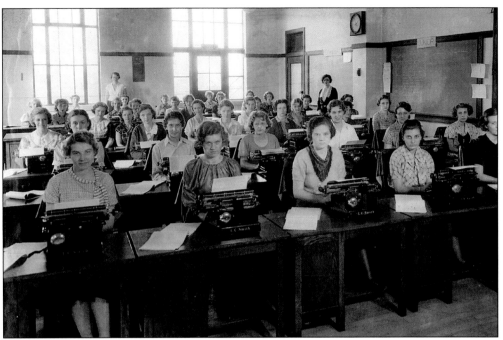

Pictured here is a "Pullman Tech" 1930s class of typing students.

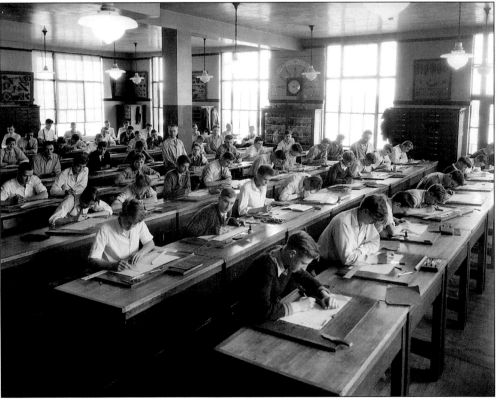

This is a "Pullman Tech" 1930s drafting class.

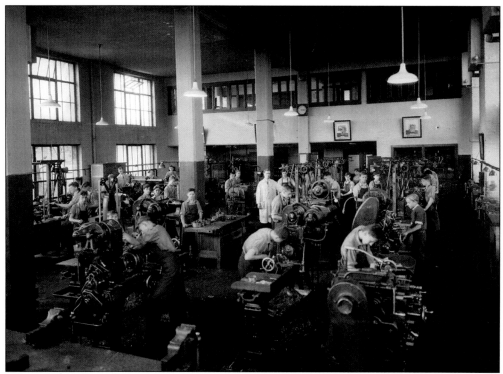

The school had a first-rate machine shop course, as can be seen in the various machine tools in this 1940 photo.

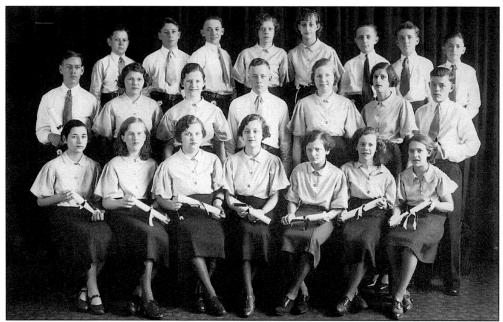

The Edgar Allen Poe School graduation class of 1931 is pictured here. Poe School is located at Langley Avenue and 106th Street. This is now a classical school in the Chicago Public School System. The building was constructed in 1906.

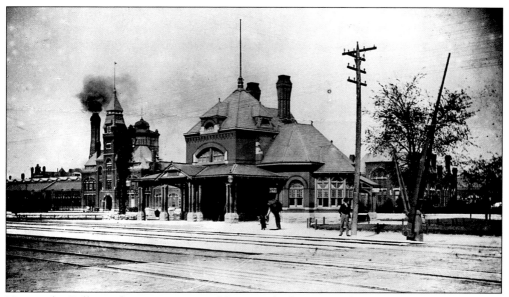

Here is the Pullman depot at its original location looking toward the administration building and water tower.

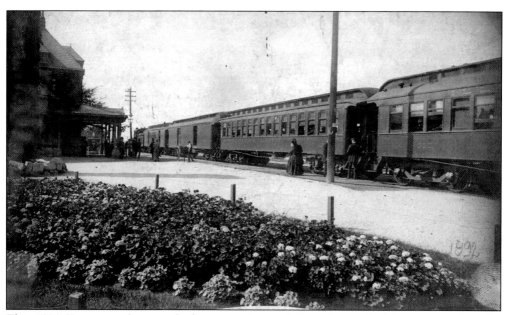

This 1892 Koopman photograph shows a train south bound out of Chicago stopped at the Pullman depot. Passengers on the train had an impressive view of the model town: the Hotel Florence, Arcade building, and the administration building.

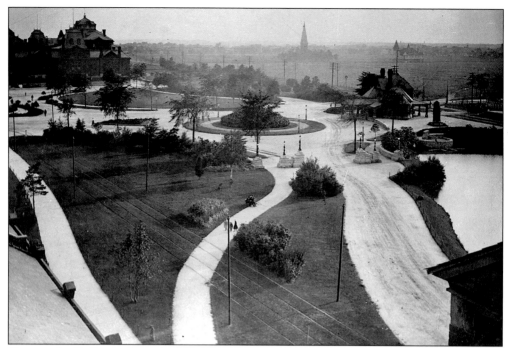

Here is the Pullman depot looking southwest from the clock tower of the administration building in 1900. The Arcade can be seen in the left background. The steeples of Holy Rosary Church, completed by S.S. Beman in 1882, and Elim Lutheran Church are also visible.

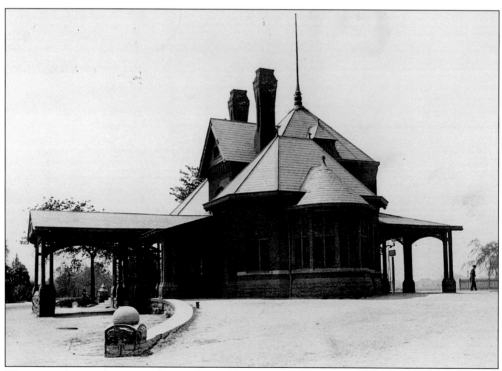

This is a rather stark view to the southwest showing the Illinois Central depot at Pullman.

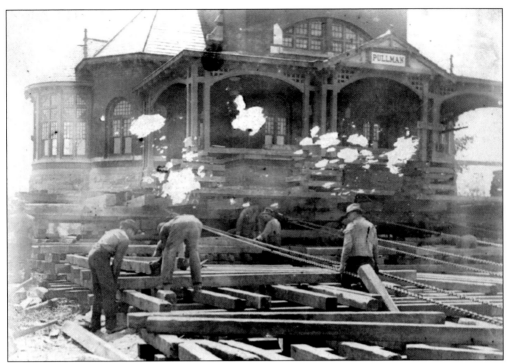

The depot on the Illinois Central Railroad commuter and main line connected the community and plant with Chicago and points south. When the railroad tracks were raised from 1915 to 1926, it was necessary to move the depot to the west side of the tracks as shown in this photo. The building has long since disappeared, and a commuter platform for local trains is now used by the community. (Photo by Martin Van der Velde.)

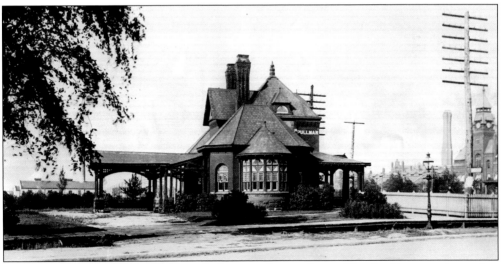

The Pullman depot is pictured here looking to the northeast. This building was located at 111th Street (Florence Boulevard) and the Illinois Central Railroad tracks. At the time that this photo was taken, the building had been moved to the west side of the tracks in order to extend Cottage Grove Avenue south. These tracks are still used to carry Amtrak and commuter passengers to and from Chicago.

Shown here is a photograph of the Pullman Railroad Station, located at 111th Street (Florence Boulevard) and Langley (Fulton) Avenue in 1940. Several shipping and express offices were located here; train service was not provided north to the city from this station. This part of the Pullman Railroad was sold to the Rock Island Railroad to service the various industrial plants in the area. The building was demolished in the 1970s.

Nine

HISTORIC PULLMAN FOUNDATION:
25 YEARS OF PRESERVATION
1973–1998

In 1968 the Pullman Civic Organization's newly formed Beman Committee (named to honor the architect of the town of Pullman) began working to link historic preservation and encourage neighborhood revitalization in the Pullman community.

Weekly meetings in Pullman homes led to a letter writing campaign to government agencies to lobby for landmark status for the community. The enthusiastic group also started to present slide shows on the historic Pullman area and include historic information in the neighborhood paper, the *Pullman Flyer*.

Because of the efforts of the Pullman Civic Organization's volunteers, South Pullman (original housing from 111th to 115th Streets and the factory buildings north of 111th to 109th Place along Cottage Grove Avenue) was designated an Illinois State Historic Landmark District in 1969. In 1971 the entire Pullman District (from 103rd to 115th Streets) received National Landmark status and in 1972 South Pullman was given City of Chicago Landmark status. Few communities in the United States can boast of all three designations. As interest in Pullman grew, the slide shows were moved to the Greenstone Church to accommodate a larger audience. More Pullman residents joined the Pullman Civic Organization (PCO), and interest in restoring the historic buildings began to grow.

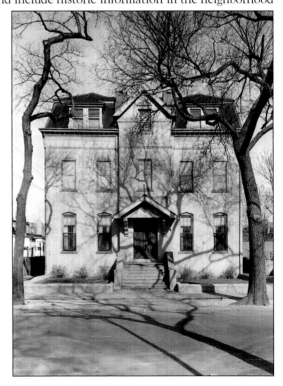

Historic Pullman Center. (Photo by Melvin C. Horn, 1955; Courtesy of Pullman Research Group.)

In 1973 the Historic Pullman Foundation (HPF) was formed because of the efforts of three individuals who recognized the need for a vehicle to deal with crises affecting the historic community. The focus of their efforts was the major public buildings and open spaces. These three individuals were David Bielenberg, Michael Shymanski, and James Rissati. One of the first activities of the foundation was to develop a new tour program and to prepare publications to make the lessons and the values of Pullman better understood. The first house tour took place in 1973—a popular event which continues to bring thousands of visitors to Pullman each year.

The first major HPF decision was to purchase the former Masonic Lodge building in 1973. Originally built as a boardinghouse for single male workers during the 1880s, the Pullman Company sold it to Palace Lodge Number 765 A.F. and M. The building was remodeled for lodge use and dedicated on September 3, 1908. After purchase by the HPF in 1973, enthusiastic Pullman volunteers spent weekends restoring the former lodge building for its new role as the Historic Pullman Center. Providing a home for both the HPF and the PCO, this building began to serve as a community meeting space and a starting point for tours and slide presentations of the Pullman Historic District. With the opening of the new HPF Visitor Center, this building is no longer used for tour groups, but serves the neighborhood well as a community center.

In December of 1973, the HPF was forced to deal with a public building in jeopardy—Market Hall was almost totally consumed by fire. The HPF board moved to purchase the damaged structure and save it from demolition. Current efforts are underway to breathe new life into this tired structure.

In 1975, after a series of auctions of historic furniture from the Hotel Florence, it was advertised that pieces of architecture would also be sold. This sale threatened the historic integrity of the Hotel Florence structure. With the assistance of the Heritage Pullman Bank and the generosity of Florence Lowden Miller (granddaughter of George M. Pullman), the hotel was purchased by the Historic Pullman Foundation.

The foundation prepared an overall plan for the historic district. The hotel became a new resource to interpret the town's history, to nurture the life of the local community, to serve visitors, and to generate revenues for the programs and activities of the foundation. Major interior and exterior restoration to the hotel included a new roof, a sprinkler system, improvements to the heating system, upgrading kitchen facilities to maintain food and beverage service, cleaning, and redecorating. The second floor of the hotel now serves as a museum showcasing the George M. Pullman suite. The HPF offices are also located on the second floor of the hotel. The Hotel Florence restaurant provides weekday dining and Sunday brunch, as well as serving as a historic site for weddings, banquets, and private parties.

With the support of a small professional staff and enthusiastic volunteers, the foundation has used their limited dollars to serve as a leader in the promotion and preservation of the Pullman Historic District. From the beginning, the HPF also began to compile archival materials and artifacts relating to the history of Pullman.

In 1978 the foundation purchased the site originally occupied by the Pullman Arcade building—the first enclosed shopping mall in the Midwest. The Arcade building had been demolished in the 1920s. An abandoned single-story American Legion building stood on the site. In 1993 the foundation completed an extensive renovation of the American Legion building, and it now serves the public as the Historic Pullman Foundation Visitor Center. Open on weekends, the visitor to the museum will enjoy an audio-visual presentation about the historic background of the

PULLMAN

THE MAN

THE CAR

THE MODEL TOWN

THE STRIKE

THE COMPANY

THE LANDMARK COMMUNITY IN CHICAGO

Pullman district and a continually expanding exhibit *Pullman . . .The Man, The Car, The Model Town, The Strike, The Company, The Landmark Community in Chicago.* The HPF Visitor Center also serves as a starting point for the many tour groups who visit Pullman. Also completed in 1993 were major improvements west and south of the hotel in the historic Arcade Park.

An eye-catching mural depicting the history of the town of Pullman is painted on the north wall of the HPF Visitor Center, welcoming visitors to the community. Through the efforts of Robert Fioretti, HPF president, John Balester, director, and Tom Torluemke, instructor, at the American Academy of Art, Inc., six students received course credit for painting the impressive Pullman mural. The students were Fred V. Gonzalez, Leslie Green-Tsuhako, Todd Macaluso, Edilberto Opio, James Pearson, and Ray Rivera. The photos were taken at the dedication of the mural in 1996.

The most recent addition to the HPF Visitor Center is the classic rail car situated on the east side of the building on a 100-foot stretch of brand new rail. Built in 1954 in Worcester, Massachusetts, at the Pullman-Standard Company factory for the Boston and Maine Railroad,

TOM TORLUEMKE (*right*) CONGRATULATING THE ARTISTS OF THE MURAL.

it was named the "Rye Beach." The sleeping car is 89 feet long and was a three-section sleeper. It was eventually sold to the Canadian National Railway and was retired from service on the VIA/Canadian Rail system in 1984. Rescued from demolition by Alex McWilliams of Dwight, Illinois, it sat on a rusted siding waiting for conversion to a private railcar. In 1998 Mr. McWilliams agreed to donate it to the HPF so that visitors would be able to view a Pullman car—the catalyst behind the building of the planned industrial model town of Pullman.

Although the majority of the original Pullman buildings still standing are located south of 111th Street, there are approximately 200 historic structures residing in the area known as North Pullman, north of 107th Street. Between 1979 and 1983, the foundation became a catalyst for the rehabilitation of several vacant and deteriorated structures which were located in this area. The foundation's rehabilitation program was coordinated with a privately financed development involving the adaptive reuse of 21 acres of industrial buildings which provided approximately 400 units of low- and middle-income apartments. These programs were assisted by an Urban Development Action Grant, Community Development Block Grant, a loan from the National Trust for Historic Preservation, and participation of CETA workers. The foundation sold two fully renovated residences for owner occupancy and other structures were sold to owners who agreed to carry out sympathetic rehabilitation and place the abandoned structures into residential use.

The HPF instituted and sponsors the First Sunday Guided Walking Tours, which take place from May through October, and co-sponsors (with the PCO) the annual Pullman House Tour on the second weekend in October. Over the years, the Historic Pullman Foundation has implemented many fund-raisers which have helped to further their goals. Some of these extremely popular events have been the following: the quarterly Victorian Dinners taking place in the Hotel Florence Restaurant; the annual Friends of the Florence, which includes high tea, an ice cream social, and an auction; and the Christmas Candlelight House Walk.

The Historic Pullman Foundation, as part of its goal to educate the public, is a key contributor to major media coverage of Pullman, continues to sponsor publications depicting Pullman's historic and contemporary relevance, prepares walking tour maps, trains volunteer tour guides, and promotes and implements the HPF tour program and other educational programs. Over the years, the HPF has encouraged and supported such events as the Pullman Porter symposium in 1993, events commemorating the 100th anniversary of the Pullman Strike in 1994, construction of the bandstand in Arcade Park, the Pullman Porter Poster and Essay Contests, the Pullman Blues Tour, and a series of lectures regarding historical and/or Pullman-related topics.

Currently the Historic Pullman Foundation serves as the catalyst for the state of Illinois project as the state, under the auspices of the Illinois Historic Preservation Agency, pursues funding for the proposed Pullman State Historic Site. The Historic Pullman Foundation continues to promote the history of the Pullman area through educational programs, tours, and activities. The work of the Historic Pullman Foundation is a shining symbol of things to come in the 118-year-old Pullman district.

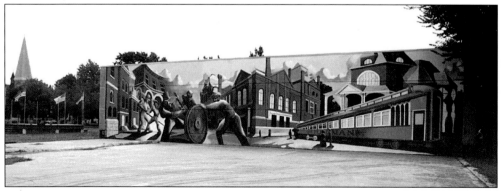

Town of Pullman
Timeline

1879 George M. Pullman purchases 3,000 acres of land south of Chicago. Only 600 acres were used for the building of the factories and first American model industrial town. Solon Spencer Beman, only 27 years old, was the architect for the town of Pullman; Nathan F. Barrett was the landscape architect.

1880 Construction of factory shops and the town of Pullman begins.

1881 First resident moves into the town on January 1, 1881. The Hotel Florence is completed. Hundreds of visitors from as far away as Europe begin to tour the model industrial town known as Pullman, Illinois.

1882 Population of Pullman is 3,500; in 1885 the population of the town is almost 9,000.

1889 Political struggles take place; Hyde Park Township (which included Pullman) was annexed to Chicago. The majority of Pullman residents voted against annexation.

1892 Original Market Hall building is destroyed by fire; rebuilt Market Hall still stands today.

1893 Nationwide Depression Labor Movement begins; wages are cut. World's Fair Columbian Exposition takes place in Chicago; Pullman becomes a major tourist attraction.

1894 Pullman strike occurs. The town of Pullman is now 13 years old.

1896 The town of Pullman wins international prize as the "World's Most Perfect Town."

1897 George Pullman dies. Robert Todd Lincoln becomes president of the Pullman Company.

1898 Illinois Supreme Court orders the Pullman Company to sell all property not used for industry. Pullman is given poor services by the City of Chicago. Population is 8,000.

1907 Pullman houses were sold between 1907 and 1909 and have been privately owned ever since.

1960 Pullman designated a "blighted" area. Roseland Chamber of Commerce financed a study which recommended tearing down the entire area between 111th and 115th Streets and

rebuilding as part of Calumet Harbor. The Civil Defense Organization from World War II reactivated to fight destruction. Proposed destruction defeated by their efforts in organizing the community. The Pullman Civic Organization was formed and established.

1969 Pullman receives State of Illinois landmark status; South Pullman (original housing from 111th Street to 115th Street including factories north of 111th Street to 109th Place along Cottage Grove Avenue).

1971 Pullman district (103rd Street–115th Street) receives National Registry designation.

1972 South Pullman (109th Place–115th Street, Cottage Grove–Langley) receives City of Chicago Landmark status.

1973 Historic Pullman Foundation (HPF) was formed to carry on work of preservation and rehabilitation in the Pullman Historic District. Annual Pullman House Tour begins; many homes begin interior and exterior restoration.

1975 Historic Pullman Foundation purchases the Hotel Florence with financial assistance from Florence Lowden Miller (granddaughter of George M. Pullman). Restoration of the hotel begins.

1991 The State of Illinois (Illinois Historic Preservation Agency) purchases the administration building, the factory shops, and the Hotel Florence for proposed Pullman State Historic Site.

1993 Pullman remains a viable community of people preserving the past and strongly committed to the future. HPF opens a new Visitor Center located on the original Arcade building site. North Pullman (approximately 104th Street to 108th Street

and

including the firehouse on 108th Street) receives City of Chicago Landmark status.

1994 Historic Pullman Foundation showcases new exhibit entitled *Pullman . . . The Man,The Car, The Model Town, The Strike, The Company, The Landmark Community in Chicago*. Labor Day parade held in Pullman to commemorate the Pullman Strike Centennial.

1998 Historic Pullman Foundation continues efforts to expand the HPF Tourism Enhancement Program, maintains its year-round educational tour program, and continues to operate the Hotel Florence Restaurant and Museum.

Historic Pullman Foundation Board of Directors, 1998

MAP OF PULLMAN, c. 1885. (Courtesy of Chicago Historical Society.)

Robert Fioretti, President	James E. Coston
Cynthia McMahon, V.P. Administration	Reverend Harlene Harden
Michael Shymanski, V.P. PropertiesReginald C. Hughes	
Judith Kubida, V.P. Public Relations	Kimberly Lowden Miller
Timothy Smith, V.P. Development	Otto Masek
Elizabeth "Betsy" Baird, Secretary	Kurt R. Nebel Jr.
Leslie J. McLain, Treasurer	Jerry B. Todd
William M. Hayden, Asst. Treasurer	C. Len Wiksten
Mario Avignone	Carol Tome, Ex-Officio (PCO)
Wilma Chiagouris	Gregory Kulis, Foundation Counsel
Robert J. Cole	Deborah Bellamy-Jawor, Executive Director

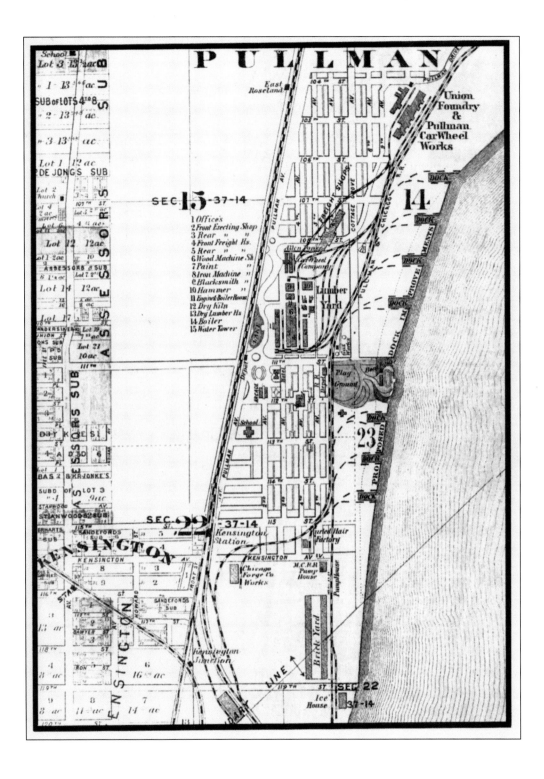

SELECTED BIBLIOGRAPHY

Buder, Stanley. *Pullman: An Experiment in Industrial Order and Community Planning, 1880–1930*. New York: Oxford University Press, 1967.

Carwardine, Rev. William H. *The Pullman Strike*. Chicago: Charles H. Kerr and Company,1894.

Doty, Mrs. Duane. *The Town of Pullman Illustrated*. Chicago: T.P. Struhsaker, Publisher, 1893, reprint 1974.

Ely, Richard T. *Pullman: A Social Study. Harper's New Monthly Magazine,* LXX, February 1885, pp. 452–466.

Koopman, H.R. *Pullman: The City of Brick*. Roseland, Illinois: H.R. Koopman, 1893.

Knoll, Charles M. *Go Pullman, Life and Times*. Rochester, New York: National Railway Historical Society.

Leavitt, Fred, text by Miller, Nancy. *Pullman, Portrait of a Landmark Community*. Chicago:1981.

Leyendecker, Liston L. *Palace Car Prince: A Biography of George M. Pullman*. Niwot, Colorado: University Press of Colorado, 1992.

Pond, Irving K. *America's First Planned Industrial Town*. The Illinois Society of Architects Monthly Bulletin, June–July, 1934, pp. 6–9.